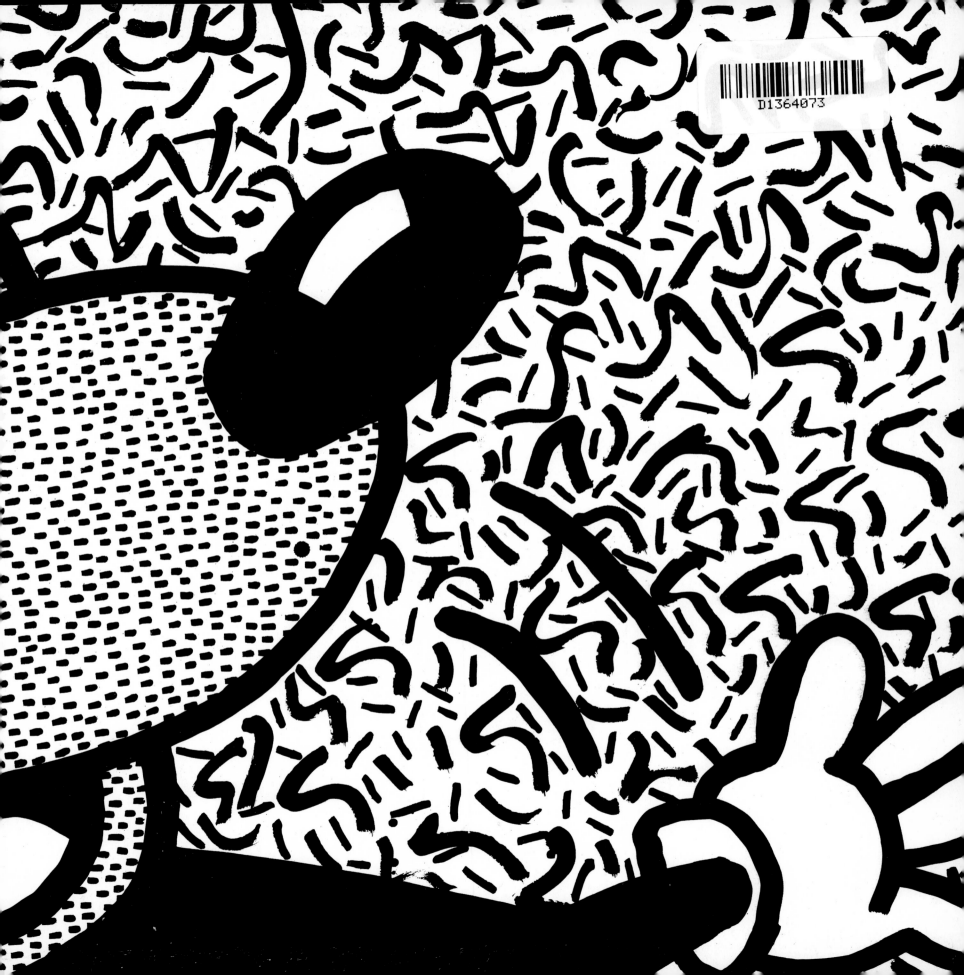

THE ART OF
MICKEY MOUSE

THE ART OF
MICKEY MOUSE

Edited by
CRAIG YOE *and* JANET MORRA-YOE

Introduction by
JOHN UPDIKE

HYPERION

NEW YORK

Endpapers: Keith Haring
Untitled (Detail), Sumi ink on paper
2 pages, each 127 x 98.42
©1981 The Estate of Keith Haring

Library of Congress Cataloging-in-Publication.Data
The Art of Mickey Mouse/ edited by
Craig Yoe and Janet Morra-Yoe;
introduction by John Updike. — 1st ed.
p. cm.
ISBN 1-56282-994-7 : $35.00 ($42.00 Can.)
1. Mickey Mouse (Cartoon character) in art — Catalogs.
2. Art, Modern — 20th century — Catalogs.
I. Yoe, Craig. II. Morra-Yoe, Janet.
N8224. M47A4 1991
704.9 ' 497415 — dc20 91-23545
 CIP

Published by

Hyperion
114 Fifth Avenue
New York, NY 10011

Designed and packaged by

Yoe-Yoe Studio
Box 425
Crugers, NY 10521

Printed in Italy
First Edition
10 9 8 7 6 5 4 3 2 1

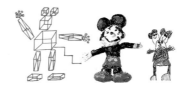

For Avarelle, Valissa, and Donovan

INTRODUCTION

JOHN UPDIKE

Top: Walt Disney's Oswald the Rabbit.
Middle: Otto Messmer's Felix the Cat.
Bottom: Early Mickey Mouse.

Felix is © Felix the Cat Productions, Inc., and appears with the kind permission of Don Oriolo.

It's all in the ears. When Mickey Mouse was born, in 1927, the world of early cartoon animation was filled with two-legged zoomorphic humanoids, whose strange half-black faces were distinguished one from another chiefly by the ears. Felix the Cat had pointed triangular ears and Oswald the Rabbit — Walt Disney's first successful cartoon creation, which he abandoned when his New York distributor, Charles Mintz, attempted to swindle him — had long floppy ears, with a few notches in the end to suggest fur. Disney's Oswald films, and the Alice animations that preceded them, had mice in them, with linear limbs, wiry tails, and ears that are oblong, not yet round. On the way back to California from New York by train, having left Oswald enmeshed for good in the machinations of Mr. Mintz, Walt and his wife Lillian invented another character based — the genesis legend claims — on the tame field mice that used to wander into Disney's old studio in Kansas City. His first thought was to call the mouse Mortimer; Lillian proposed instead the less pretentious name Mickey. Some-

where between Chicago and Los Angeles, the young couple concocted the plot of Mickey's first cartoon short, *Plane Crazy*, co-starring Minnie and capitalizing on 1927's Lindbergh craze. The next short produced by Disney's fledgling studio — which included, besides himself and Lillian, his brother Roy, and his old Kansas City associate, Ub Iwerks — was *Gallopin' Gaucho*, and introduced a fat and wicked cat who did not yet wear the prosthesis that would give him his name of Pegleg Pete. The third short, *Steamboat Willie*, incorporated that brand-new novelty, a sound track, and was released first, in 1928. Mickey Mouse entered history, as the most persistent and pervasive figment of American popular culture in this century.

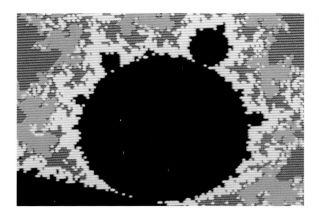

His ears are two solid black circles, no matter the angle at which he holds his head. Three-dimensional images of Mickey Mouse — toy dolls, or the papier-mâché heads the grotesque Disneyland Mickeys wear — make us uneasy, since the ears inevitably exist edgewise as well as frontally. These ears properly belong not to three-dimen-sional space but to an ideal realm of notation, of symbolization, of cartoon resilience and indestructibility. In drawings, when Mickey is in profile, one ear is at the back of his head like a spherical ponytail, or like a secondary bubble in a computer-generated Mandelbrot set. We accept it, as we accepted Li'l Abner's hair always being parted on the side facing the viewer. A surreal optical consistency is part of the cartoon world, halfway between our world and the plane of pure signs, of alphabets and trademarks.

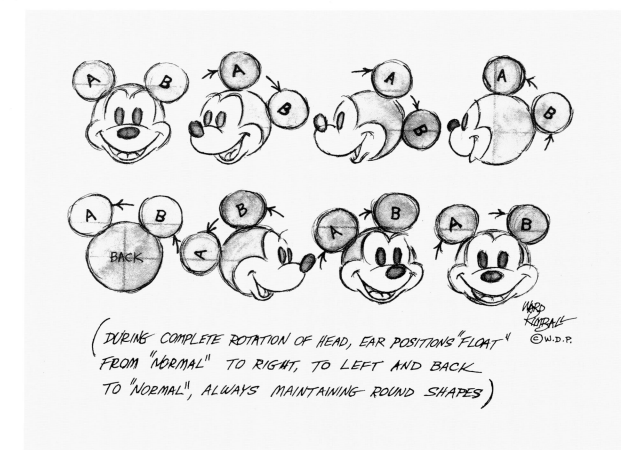

Above: A Mandelbrot set.
Right: The mystery of Mickey's ears drawn by veteran Disney animator Ward Kimball.

Mandelbrot set ©1986 Scott Camazine.
Courtesy: Photo Researchers, Inc.

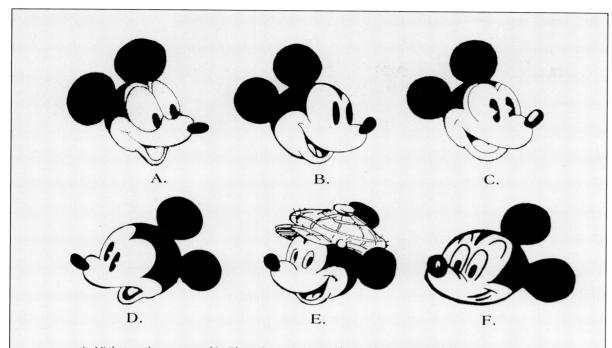

A. Mickey as he appeared in *Plane Crazy* (1928) with goggle eyes. B. Mickey in animated cartoons of the early Thirties with solid oblong pupils. C. Mickey with eye rims and nicked pupils, in graphic art of the early Thirties. D. Without eye rims, in comic strip of 1934, drawn by Floyd Gottfredson. E. Mickey with oblong humanoid eyes, as invented by Ward Kimball, on a studio outing invitation in 1938. F. Mickey in a comic strip of the Seventies with eyes devolving toward earlier shape.

In the sixty-four years since Mickey Mouse's image was promulgated, the ears, though a bit more organically irregular and flexible than the classic 1930s appendages, have not been essentially modified. Many other modifications have, however, overtaken that first crude cartoon, born of an era of starker stylizations. White gloves, like the gloves worn in minstrel shows, appeared after those early Twenties movies, to cover the black hands. The infantile bare chest and shorts with two buttons were phased out in the Forties. The eyes have undergone a number of changes, most drastically in the late Thirties, when, as some historians mistakenly claim, they acquired pupils. Not so: the old eyes, the black oblongs that acquired a nick of reflection in the sides, *were* the pupils; the eye-whites filled the entire space beneath Mickey's cap of black, its widow's peak marking the division between these enormous oculi. This can be seen clearly in the face of the classic Minnie; when she bats her eyelids, their lashed shades lower over the full width of what might be thought to be her brow. But all the old animated animals were built this way from Felix the Cat on; Felix had lower lids, and the Mickey of *Plane Crazy* also. So it was an evolutionary misstep that, beginning in 1938, replaced the old shiny black pupils with entire oval eyes, containing pupils of their own. No such mutation has overtaken Pluto, Goofy, or Donald Duck. The change brought Mickey closer to us humans, but also took away something of his vitality, his alertness, his bug-eyed cartoon readiness for adventure. It made him less abstract, less iconic, more merely cute and dwarfish. The original Mickey, as he scuttles and bounces through those early animated shorts, was angular and wiry, with much of the impudence and desperation of a true rodent. He was gradually rounded to the proportions of a child, a regression sealed by his Fifties manifestation as the genius of the children's television show, *The Mickey Mouse Club*, with its live Mouseketeers. But most of the artists in this album, though too young to have grown up, as I did, with the old form of Mickey, have instinctively reverted to it; it is the bare-chested basic Mickey, with his yellow shoes and

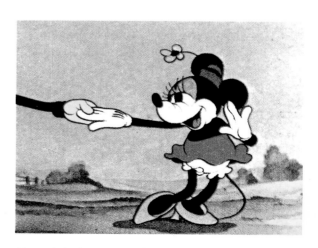

Above: Minnie Mouse with eyes at half-mast.

oval buttons on his shorts, who is the icon, beside whom his modified later version is a mere mousy trousered pipsqueak.

His first, iconic manifestation had something of Chaplin to it: he was the little guy, just over the border of the respectable. His circular ears, like two minimal cents, bespeak the smallest economic unit, the overlookable democratic man. His name has passed in the language as a byword for the small, the weak — a "Mickey Mouse operation" means an undercapitalized company or minor surgery. Children of my generation — wearing our Mickey Mouse watches, prying pennies from our Mickey Mouse piggy banks (I won one in a third-grade spelling bee, my first intellectual triumph), following his running combat with Pegleg Pete in the daily funnies, going to the local movie-house movies every Saturday afternoon and cheering when his smiling visage burst onto the screen to introduce a cartoon — felt Mickey was one of us, a bridge to the adult world of which Donald Duck was, for all of his childish sailor suit, an irascible, tyrannical member. Mickey didn't seek trouble, and he didn't complain; he rolled with the punches, and surprised himself as much as us when, as

in *The Little Tailor*, he showed warrior resourcefulness and won, once again, a blushing kiss from dear, all but identical, Minnie. His minimal, decent nature meant that he would yield, in the Disney animated cartoons, the starring role to combative, sputtering Donald Duck and even to Goofy, with his "gawshes" and Gary Cooper-like gawkiness. But for an occasional comeback like the Sorcerer's Apprentice episode of *Fantasia*, and last year's rather souped-up *The Prince and the Pauper*, Mickey was through as a star by 1940. But, as with Marilyn Monroe when her career was over, his life as an icon gathered strength. The America that is not symbolized by that imperial Yankee Uncle Sam is symbolized by Mickey Mouse. He is America as it feels to itself — plucky, put-on, inventive, resilient, good-natured, game.

Like America, Mickey has a lot of black blood. This fact was revealed to me in conversation by Saul Steinberg, who, in attempting to depict the racially mixed reality of New York streets for the supersensitive and race-blind *New Yorker* of the Sixties and Seventies, hit upon scribbling numerous Mickeys as a way of representing what was jauntily and scruffily

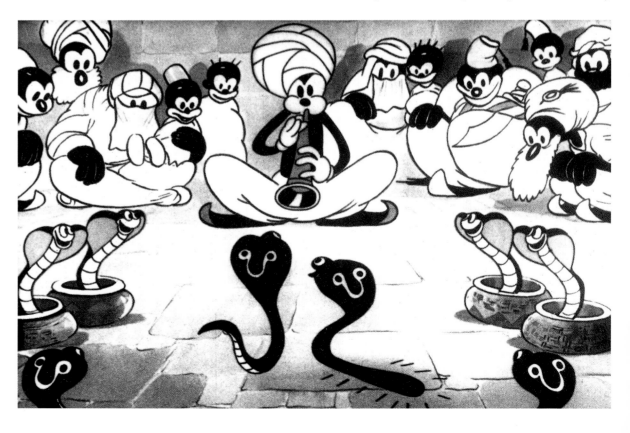

Above: Mickey in his jiving mood, strutting on stage.
Right: Mickey in full turban in *Mickey in Arabia*, 1932

and unignorably there. From just the way Mickey swings along in his classic, trademark pose, one three-fingered gloved hand held on high, he is jiving. Along with round black ears and yellow shoes, Mickey has soul. Looking back to such early animations as the early Looney Tunes' Bosko and Honey series (1930-36) and the Arab figures in Disney's own *Mickey in Arabia* of 1932, we see that blacks were drawn much like cartoon animals, with round button noses and great white eyes creating the double arch of the curious peaked skullcaps. Cartoon characters' rubberiness, their jazziness, their cheerful buoyance and idleness, all chimed with popular images of African Americans, earlier embodied in minstrel shows and in Joel Chandler Harris's tales of Uncle Remus, which Disney was to make into an animated feature, *Song of the South*, in 1946.

Up to 1950, animated cartoons, like films in general, contained caricatures of blacks that would be unacceptable now; in fact, *Song of the South* raised objections from the NAACP when it was released. In recent reissues of *Fantasia*, two Nubian centaurettes and a pickaninny centaurette who shines the others' hooves have been edited out. Not even the superb crows section of *Dumbo* would be made now. But there is a sense in which all animated cartoon characters are more or less black. Steven Spielberg's hectic tribute to animation, *Who Framed Roger Rabbit*, has them all, from the singing trees of Silly Symphonies to Daffy Duck and Woody Woodpecker, living in a Los Angeles ghetto, Toonville. As blacks were second-class citizens with entertaining qualities, so the animated shorts were second-class movies, with unreal actors, who mocked and illuminated from underneath the real world, the live-actor cinema. Of course, even in a ghetto there are class distinctions. Porky Pig and Bugs Bunny have homes that they tend and defend, whereas Mickey started out, like those other raffish stick figures and dancing blots from the Twenties, as a free spirit, a wanderer. As Richard Schickel has pointed out, "The locales of his adventures throughout the 1930s ranged from the South Seas to the Alps to the deserts of Africa. He was, at various times, a gaucho, teamster, explorer, swimmer, cowboy, fireman, convict, pioneer, taxi driver, castaway, fisherman, cyclist, Arab, football player, inventor, jockey, storekeeper, camper, sailor, Gulliver, boxer" and so forth. He was, in short, a rootless vaudevillian who would play any part that the bosses at Disney Studios assigned him. And though the comic strip, which still persists, has fitted him with all of a white man's household comforts and headaches, it is as an unencumbered drifter whistling along on the road of hard knocks, ready for whatever adventure waits at the next turning, that he lives in our minds.

Cartoon characters have soul as Carl Jung defined it in his *Archetypes and the Collective Unconscious*: "soul is a life-giving demon who plays his elfin game above and below human existence." Without the "leaping and twinkling of the soul," Jung says, "man would rot away in his greatest passion, idleness." The Mickey Mouse of the Thirties shorts was a whirlwind of activity, with a host of unsuspected skills and a reluctant heroism that rose to every occasion. Like Chaplin and Douglas Fairbanks and Fred Astaire, he acted out our fantasies of endless nimbleness, of perfect weightlessness. Yet, withal, there was nothing aggressive or self-promoting about him, as there was about, say, Popeye. Disney, interviewed in the

Above: The comic strip Mickey surrounded by all the comforts and headaches of home.

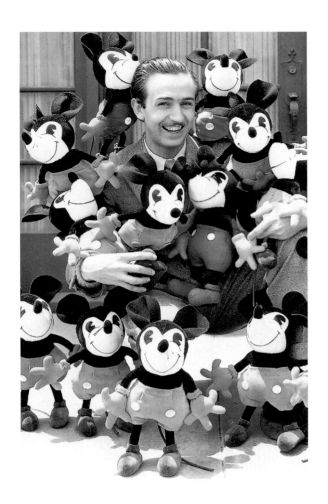

Above: Walt Disney c. 1930 surrounded by Mickey dolls.

Thirties, said, "Sometimes I've tried to figure out why Mickey appealed to the whole world. Everybody's tried to figure it out. So far as I know, nobody has. He's a pretty nice fellow who never does anybody any harm, who gets into scrapes through no fault of his own, but always managed to come up grinning." This was perhaps Disney's image of himself; for twenty years he did Mickey's voice in the films, and would often say, "there's a lot of the Mouse in me." Mickey was a character created with his own pen, and nurtured on Disney's memories of his mouseridden Kansas City studio and of the Missouri farm where his struggling father tried for a time to make a living. Walt's humble, scrambling beginnings remained embodied in the mouse, whom the Nazis, in a fury against the Mickey-inspired Allied legions (the Allied code word on D-Day was "Mickey Mouse"), called "the most miserable ideal ever revealed ... mice are dirty."

But was Disney, like Mickey, just "a pretty nice fellow"? He was until crossed in his driving perfectionism, his Napoleonic capacity to marshal men and take risks in the service of an artistic and entrepreneurial vision. He was one of those great Americans, like Edison and Henry Ford, who invented themselves in terms of a new technology. The technology — in Disney's case, film animation — would have been there anyway, but only a few driven men seized the full possibilities, and made empires. In the dozen years between *Steamboat Willie* and *Fantasia*, the Disney studios took the art of animation to heights of ambition and accomplishment it would never have reached otherwise, and Disney's personal zeal was the animating force. He created an empire of the mind, and its emperor was Mickey Mouse.

The Thirties were Mickey's conquering decade. His image circled the globe. In Africa, tribesmen painfully had tiny mosaic Mickey Mouses inset into their front teeth, and a South African tribe refused to buy soap unless the cakes were embossed with Mickey's image, and a revolt of some native bearers was quelled when the safari masters projected some Mickey Mouse cartoons for them. Nor were the high and mighty immune to Mickey's elemental appeal — King George V

and Teddy Roosevelt insisted that all film showings they attended include a dose of Mickey Mouse. But other popular phantoms, like Felix the Cat, have faded, where Mickey has settled into the national collective consciousness. The television program revived him for my children's generation, and the theme parks make him live for my grandchildren's. Yet survival cannot be imposed through weight of publicity; Mickey's persistence springs from something unhyped, something timeless in the image that has allowed it to pass in status from a fad to an icon.

To take a bite out of our imaginations, an icon must be simple. The ears, the wiggly tail, the red shorts, give us a Mickey. Donald Duck and Goofy, Bugs Bunny and Woody Woodpecker are inextricably bound up with the draughtmanship of the artists who make them move and squawk, but Mickey floats free. It was Claes Oldenburg's work that first alerted me to the fact that Mickey Mouse had passed out of the realm of commercially generated image into that of artifact, so that the basic configuration, like that of hamburgers and pay telephones, could be used as an immediately graspable referent in a piece of art. The young Andy Warhol committed Dick Tracy, Nancy, Batman, and Popeye to canvas, but not, until 1981, Mickey. Perhaps Pop Art could most resonantly recycle comic strips with a romantic appeal to adolescents. Mickey's appeal is pre-romantic, a matter of latency's relatively abstract manipulations. Hajime Sorayama's shiny piece of airbrush art and Gary Baseman's scribbled scraps, both in this volume, capture textures of the developmental stage at which Mickey's image penetrates. Sorayama, by adding a few features not present in the cartoon image — supplying knobs to the elbows and knees and some anatomy to the ears — subtly carries forward Disney creativity without violating it. Baseman's reference to Mouseketeer ears is important; their invention further abstractified Mickey and turned him into a kind of power we could put on while remaining, facially, ourselves. The ancient notion of transforming hat crowns, dunce caps, "thinking caps," football helmets, spaceman gear acquires new potency in the age of the television set, which sports its

own "ears," gathering magic from the air. As John Berg's painting shows, ears are everywhere. To recognize Mickey, as Heinz Edelmann's drawing demonstrates, we need very little. Round ears will do it. A new Disney gadget, advertised on television, is a camera-like box that spouts bubbles when a key is turned; the key consists of three circles, two mounted on a larger one, and the image is unmistakably Mickey. Like yin and yang, like the Christian cross and the star of Israel, Mickey can be seen everywhere a sign, a rune, a hieroglyphic trace of a secret power, an electricity we want to plug into. Like totem poles, like African masks, Mickey stands at that intersection of abstraction and representation where magic connects.

Milton Glaser's charming reprise of Mickey wearing glasses, though still engaged in his jivey stride, lightly touches on the question of iconic mortality. Usually, cartoon figures do not age, and yet their audience does age, as generation succeeds generation, so that a weight of allusion and sentimental reference increases. To the movie audiences of the early Thirties, Mickey Mouse was a piping-voiced live wire, the latest thing in entertainment; by the time of the Sorcerer's Apprentice episode of *Fantasia* he was already a somewhat sentimental figure, welcomed back. *The Mickey Mouse Show*, with its slightly melancholy pack-leader Jimmie Dodd, created a Mickey more removed and marginal than in the first. The generation that watched it grew up into the rebels of the Sixties, to whom Mickey became camp, a symbol of U.S. cultural fast food, with a touch (see the drawing by Rick Griffin) of the old rodent raffishness. Politically, Walt, stung by the studio strike of 1940, moved to the right, but Mickey remains one of the Thirties proletariat, not uncomfortable in the cartoon-rickety, cheerfully verminous crash pads of the counterculture. At the Florida and California theme parks, Mickey manifests himself as a short real person wearing an awkward giant head, costumed as a ringmaster; he is in a danger, in these Nineties, of seeming not merely venerable kitsch but part of the great trash problem, one more piece of visual litter being moved back and forth by the bulldozers of consumerism.

But never fear, his basic goodness will shine through.

Beyond recall, perhaps, is the simple love felt by us of the generation that grew up with him. I remember crying when the local newspaper, cutting down its comic pages to help us win World War II, eliminated the Mickey Mouse strip. I was old enough, nine or ten, to write an angry letter to the editor. In fact, the strips had been eliminated by the votes of a readership poll, and my indignation and sorrow stemmed from my incredulous realization that not everybody loved Mickey Mouse as I did. In an account of my boyhood written over thirty years ago, "The Dogwood Tree," I find these sentences concerning another boy, a rival: "When we both collected Big Little Books, he outbid me for my supreme find (in the attic of a third boy), the first Mickey Mouse. I can still see that book. I wanted it so badly, its paper tan with age and its drawings done in Disney's primitive style, when Mickey's black chest is naked like a child's and his eyes are two nicked oblongs." And I once tried to write a short story called "A Sensation of Mickey Mouse," trying to superimpose on adult experience, as a shiver-inducing revenant, that indescribable childhood sensation — a rubbery taste, a licorice smell, a feeling of supernatural clarity and close-in excitation that Mickey Mouse gave me, and gives me, much dimmed by the years, still. He is a "genius" in the primary dictionary sense of "an attendant spirit," his vulnerable bare black chest, his touchingly big yellow shoes, the mysterious place at the back of his shorts where his tail came out, the little cleft cushion of a tongue, red as a valentine and glossy as candy, always peeping through the catenary curves of his undiscourageable smile. Not to mention his ears.

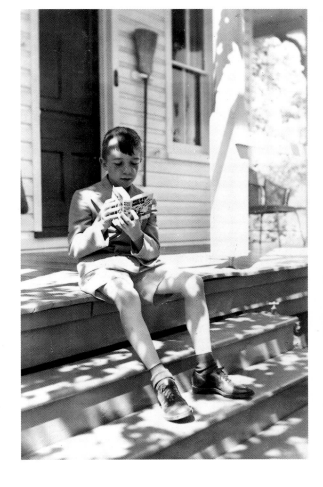

For many of these facts I am indebted to Mickey Mouse: Fifty Happy Years, *introduced by David Bain and edited by Bain and Bruce Harris (Harmony Books, 1977). Another valuable source was* Enchanted Drawings: The History of Animation, *by Charles Solomon (Alfred A. Knopf, 1989).*

Above: John Updike at age nine, reading about his favorite hero, in 1941.
Photo: Linda Updike.

FOREWORD

CRAIG YOE and
JANET MORRA-YOE

We have loved Mickey Mouse since we first saw him flicker across the TV screen. On weekday afternoons we'd draw the living room curtains, put on our Mouseketeer ears, and enter his little black and white world.

You could say we grew up with Mickey, except that we didn't quite grow up. Now we're big kids, and we still love to have Mickey around. Framed pictures of Mickey look down at us from our studio walls. Mickey Mouse T-shirts hang on our skinny frames. And, since our red and yellow, black and white bathroom is lined floor to ceiling with Mickey memorabilia, he's the first thing we see in the morning and the last thing we see at night.

Mickey is always floating around in our brains, so when we hit upon the idea of creating a book of artists' interpretations of Walt's mouse, it seemed a natural.

Some great artists such as Warhol, Haring, Thiebaud, and Paolozzi had already captured The Mouse. We commissioned Mickey Mouses especially for this book from our other favorite artists, illustrators, animators, sculptors, cartoonists, and designers.

German artist Heinz Edelmann, who designed the Beatles' *Yellow Submarine* movie, agreed to contribute, as did R.O. Blechman, who creates shorter but no less mind-expanding animation.

Noted children's book illustrators — among them Maurice Sendak, William Steig, William Joyce, Lane Smith, and Michael Hague — are represented here.

Counterculture artists R. Crumb, Rick Griffin, and Victor Moscoso, the geniuses behind *Zap Comix*, created their own strange Mickeys. Three younger artists with *Zap* mentalities also contributed: Georganne Deen, Mary Fleener, and Gary Panter — the father of Punk Art.

Other contributors include the renowned designer/illustrators Milton Glaser, Seymour Chwast, and Frank Olinsky, who was instrumental in designing the chameleon-like MTV logo. Bradbury Thompson, who has designed more than 100 U.S. postage stamps, created a Mickey stamp, and Saul Bass, who has designed opening title sequences for such classic films as *Anatomy of a Murder*, put Mickey in the Mojave.

That all-American art form, the comic strip, is represented by Charles Schulz, whose brilliant *Peanuts* redefined the medium. Jack Kirby, the recognized king of the adventure comic book, transformed Mickey into a superhero. John Stanley, writer and illustrator of the hilarious *Little Lulu* comic books, also worked at the art studio that produced the original Mickey Mouse watch 58 years ago. He came out of retirement to draw a Mickey Mouse timepiece for us.

Two artists envisioned Mickey in the past and future. Howard Finster, who reigns over the world of Folk Art with his visionary creations, sent Mickey on vacation to a future world like no other. And William Stout, a leading dinosaur authority and illustrator, charted Mickey's evolutionary course.

Noted Japanese artists Hajime Sorayama, Suzy Amakane, and Katsuya Ise, like their fellow countrymen, share a deep love for Mickey. We found artists from Brazil, Russia, France, Poland, Germany, Belgium, Britain, Canada, and Holland who are equally enamored of The Mouse and eager to be represented.

One notable contributor is an American icon himself. Michael Jackson shares our deep affection for things Disney and, knowing that he loves to draw, we asked him to participate.

Our book focuses on artists outside the Disney organization. However, we couldn't help but include the wacky look at Mickey provided by Ward

Kimball, one of Walt's handpicked "nine old men." Fine artists, Folk artists, animators, and illustrators. Punk artists, and cartoonists. Pop artists, pop star. Artists from Asia, South America, Europe, the Soviet Union, and America. The famous and the hitherto unknown. The Mouse is perhaps the only muse that could have brought together such a varied roster of talented artists eager to lift their brushes, chisels, needles and thread, ink pens, cameras, and computer mouses in tribute. To Mickey Mouse — long may he live!

New York City
September, 1991

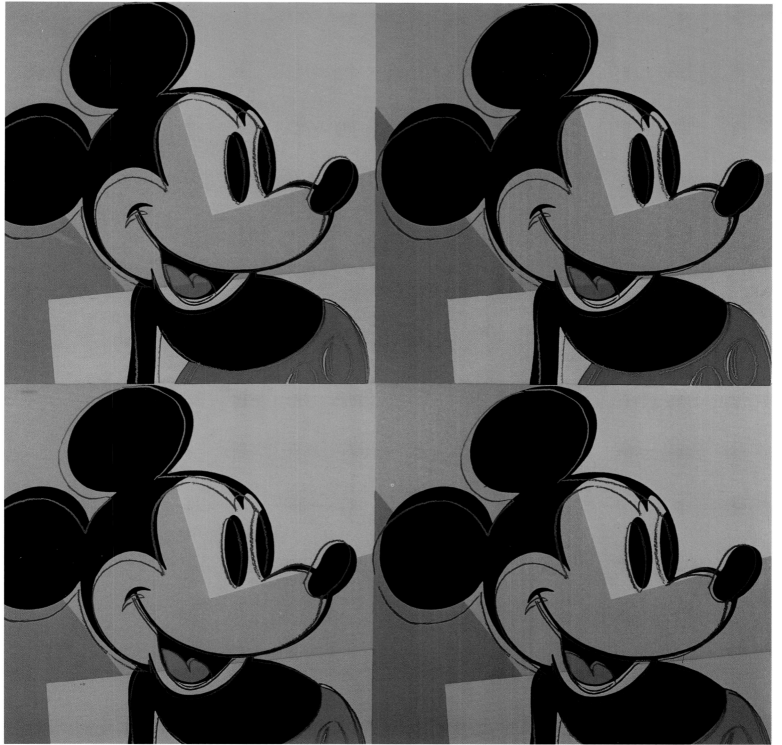

ANDY WARHOL

Mickey Mouse (Myths Series), 1981
Silkscreen ink on synthetic polymer paint on canvas
152.4 x 152.4

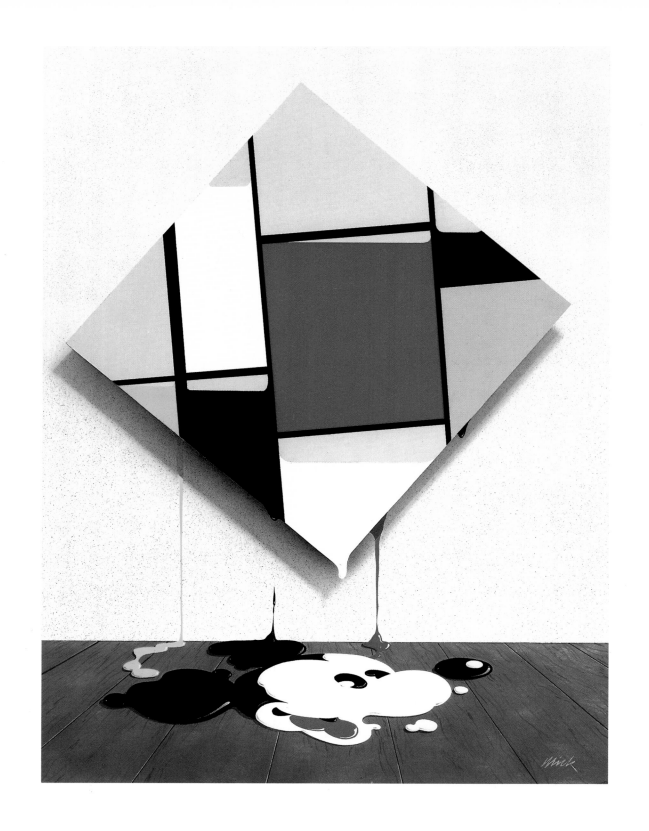

MICK HAGGERTY
Mickey-Mondrian, 1978
Acrylic on board
46.3 x 35.5

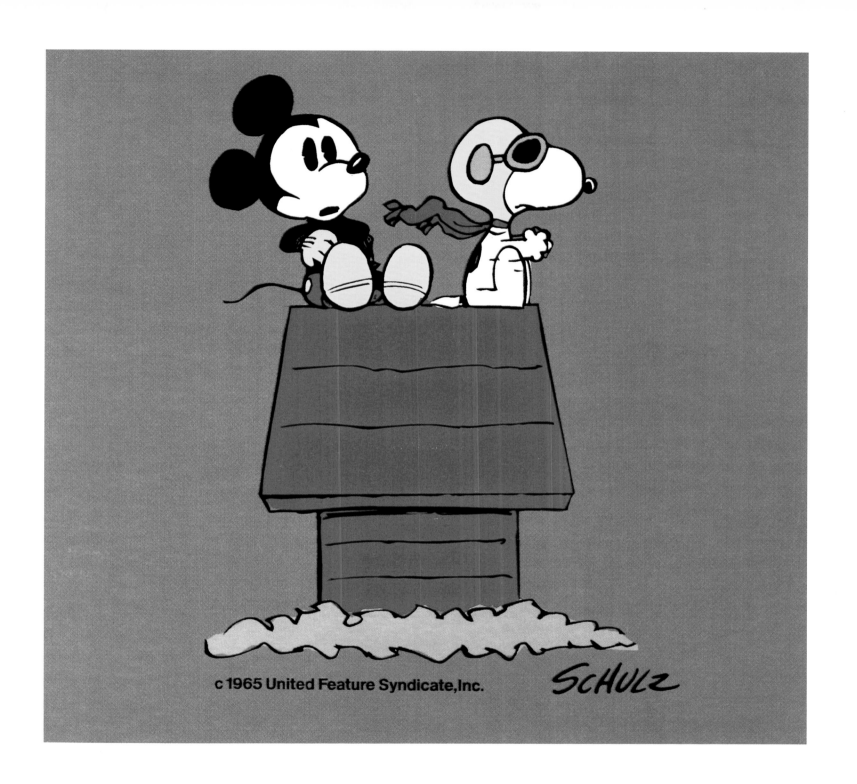

c 1965 United Feature Syndicate,Inc.

SCHULZ

CHARLES M. SCHULZ

Untitled, 1991
Pen and ink, computer colored
22.9 x 24.7

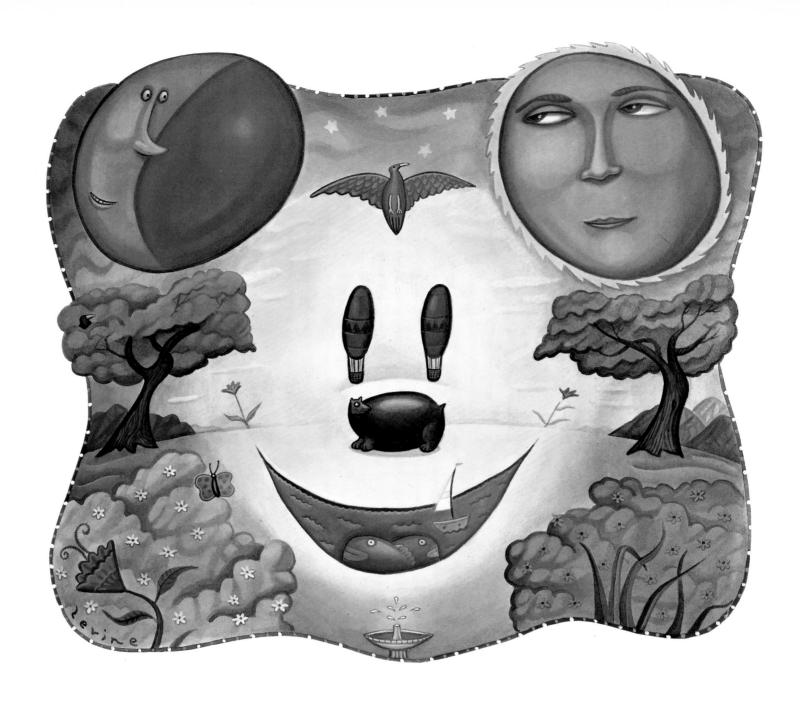

ANDY LEVINE
Mickeyscape
Acrylic
37.5 X 40

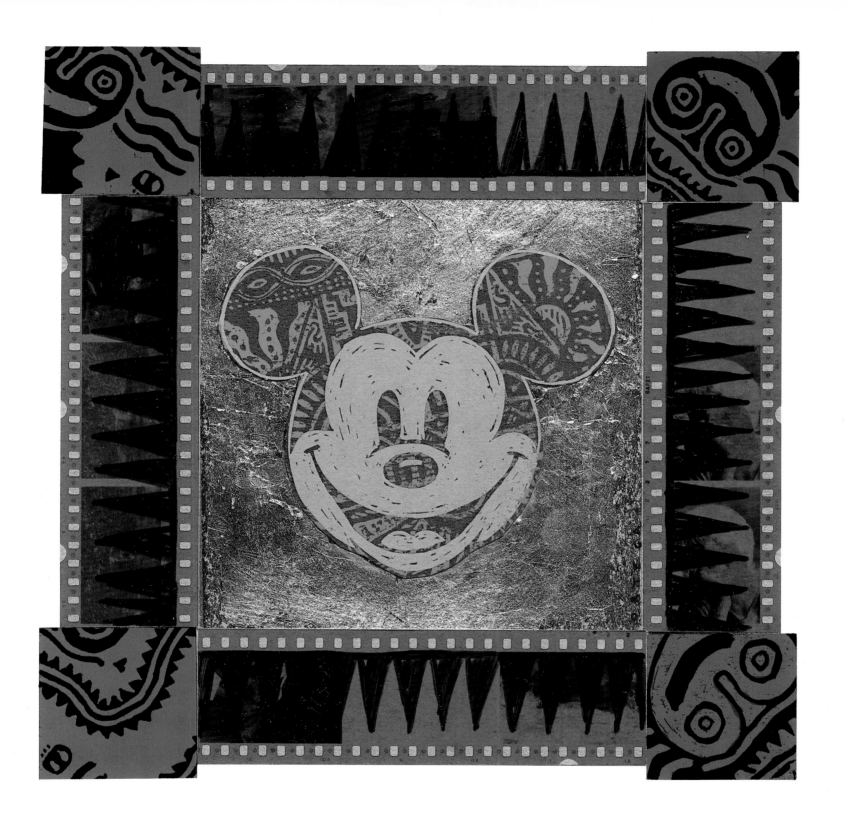

JOSÉ ORTEGA
GuantanaMickey
Scratchboard, gold leaf, film
19 x 19

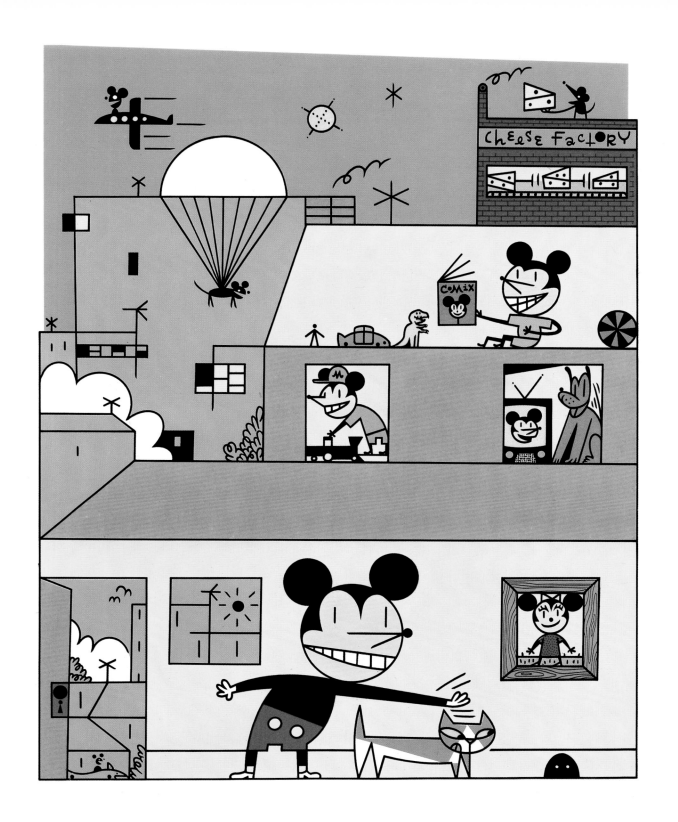

J. D. KING
The House of Mouse
Ink and color film
33 x 25

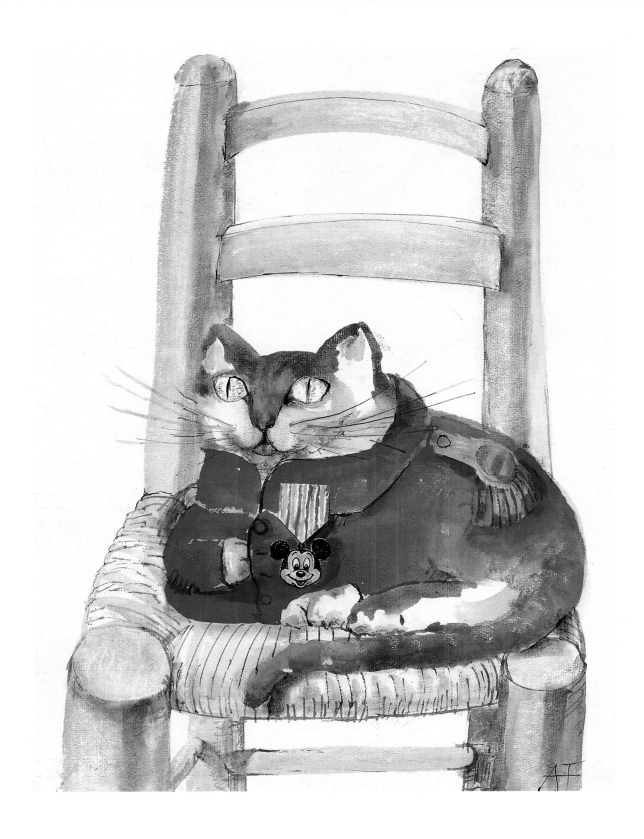

ANDRÉ FRANÇOIS

The Battle of Trafalgar, 1987-91
Collage and mixed media
61.6 x 46.4

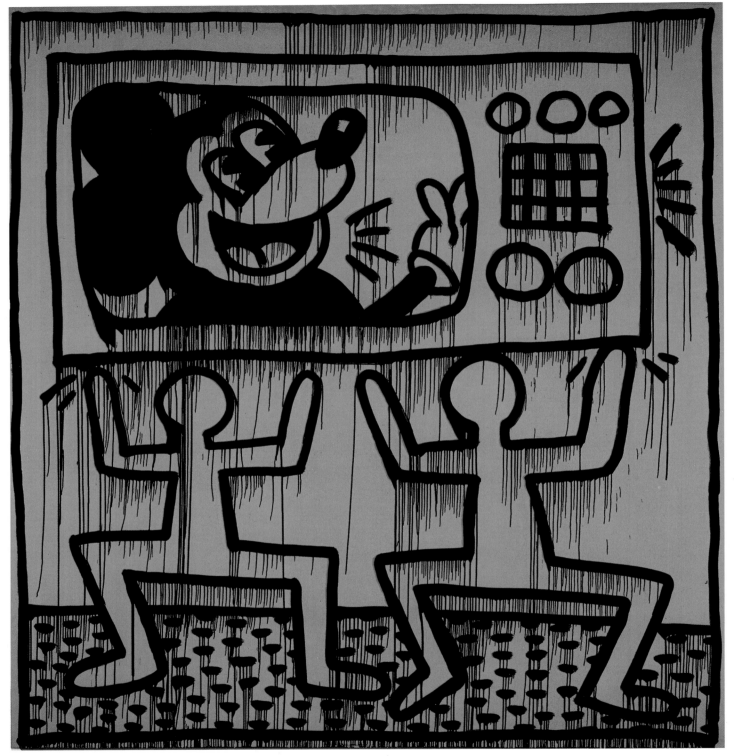

KEITH HARING

Untitled, 1982
Sumi ink and acrylic on canvas
246.5 x 235.1

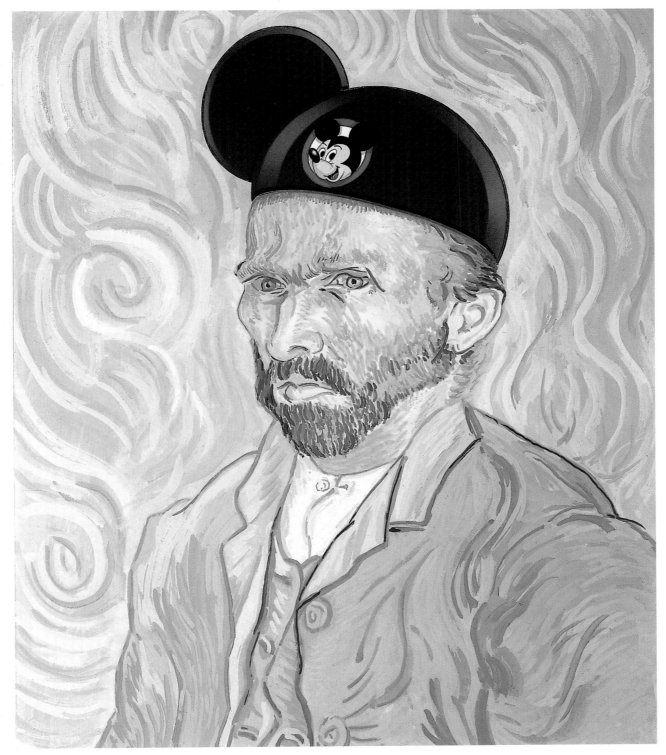

BOB BUCCELLA
Vincent Van Goghs to Disneyland, 1987
Acrylic and gouache
24.8 x 21

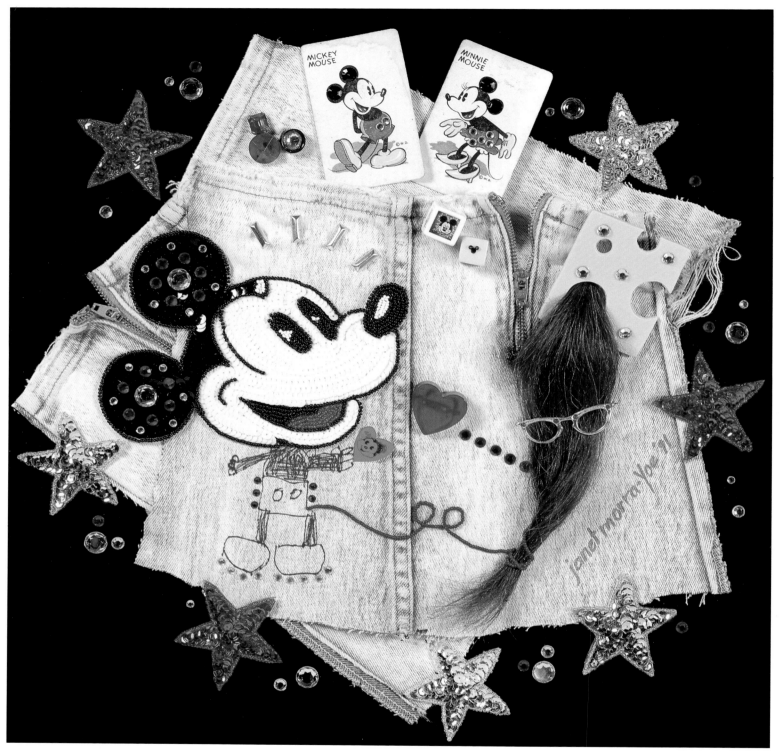

JANET MORRA-YOE
The Game of Love
Mixed media
50 x 50

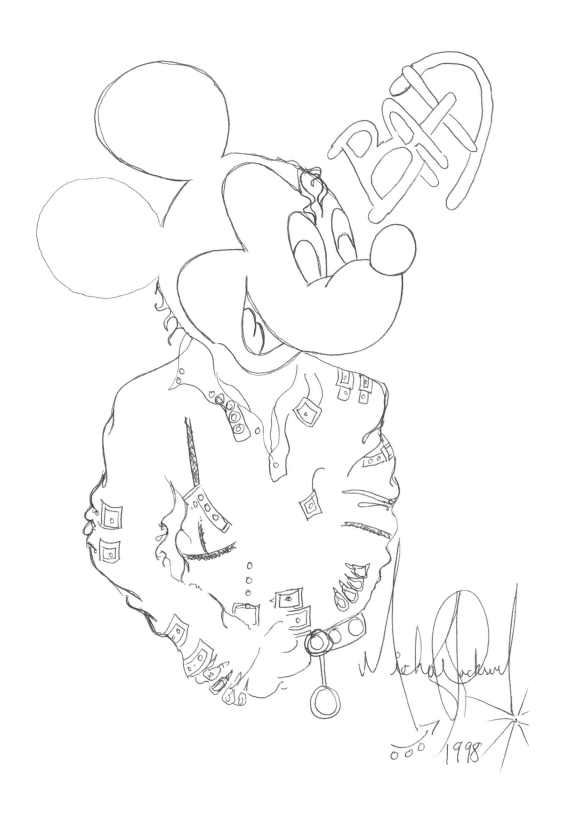

MICHAEL JACKSON
Bad, 1998
Pen
28 x 21.6

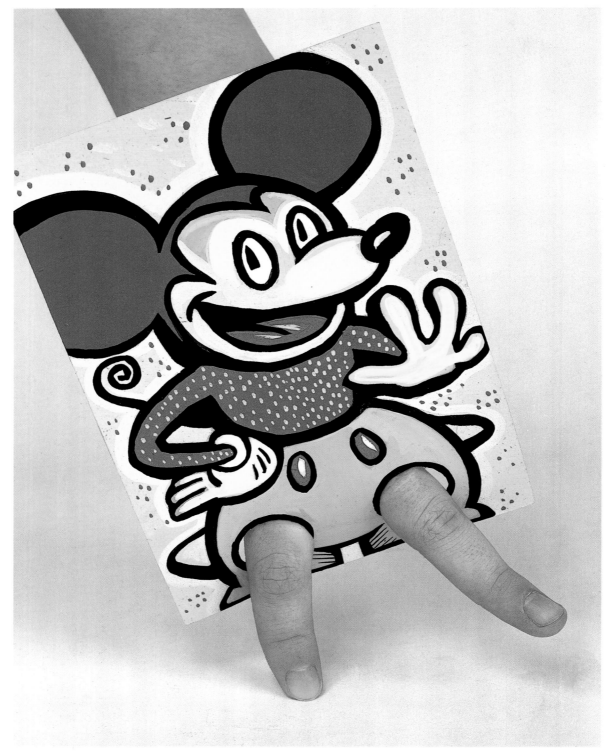

Photo: Sherman Bryce Model: Avarelle Yoe

PAMELA HOBBS
Dancing Mickey
Acrylic on paper
20 x 10.7

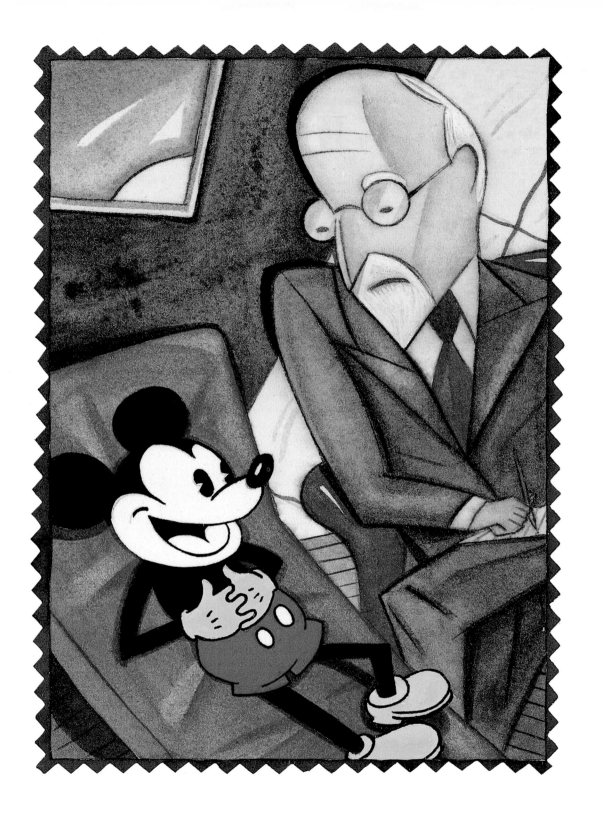

RUSSELL O. JONES

*The Psychoanalysis
of Mickey*, 1988
Water color
14 x 10

How To Draw Seven Circles

BY SEYMOUSE CHWAST

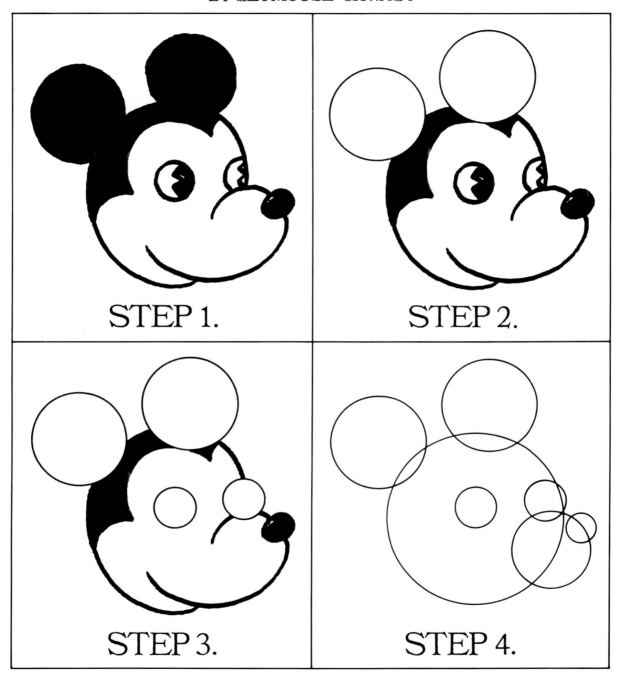

STEP 1.

STEP 2.

STEP 3.

STEP 4.

Seymour Chwast
How To Draw 7 Circles
Pen
43.3 x 28

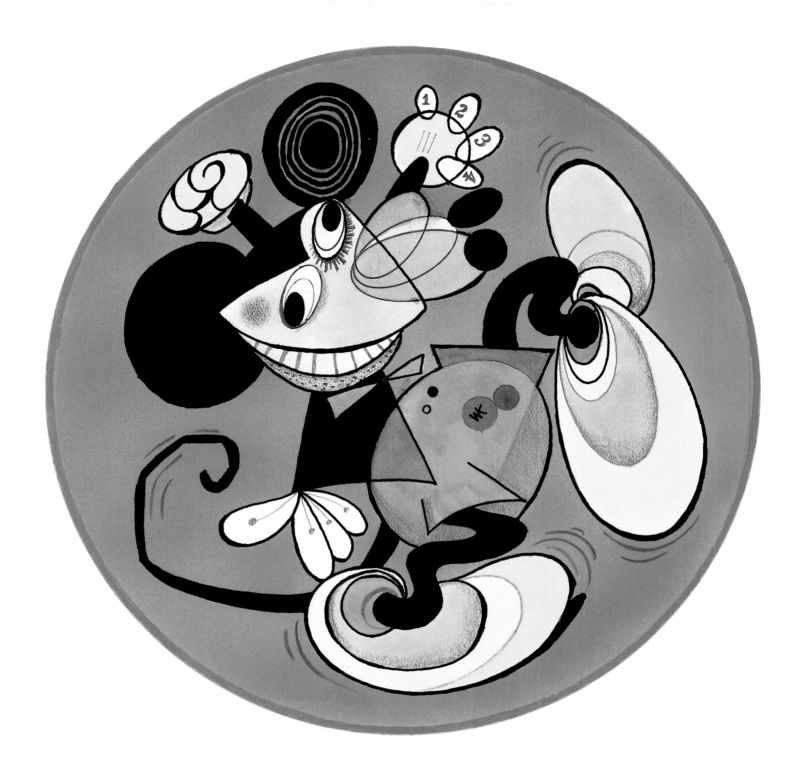

WARD KIMBALL

*Design for Experimental
Waldorf Salad Plate*
Acrylic, ink and pencil
29 x 29

SUZY AMAKANE
Look for Minnie!
Acrylic on canvas
100 x 100

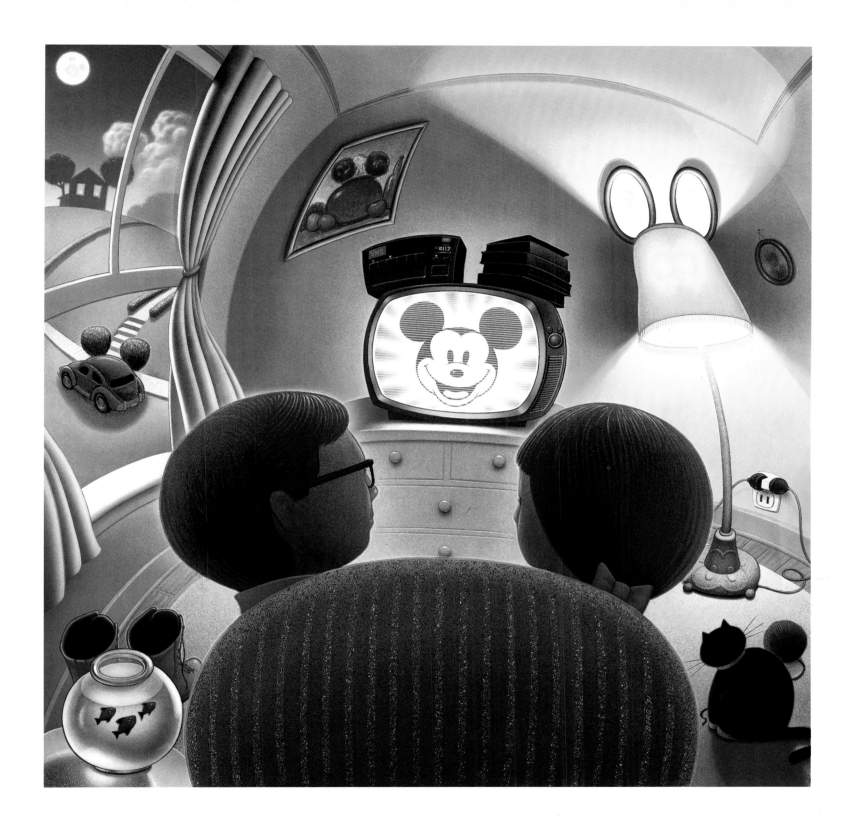

JOHN BERG
Echoes
Acrylic
42.5 x 42.5

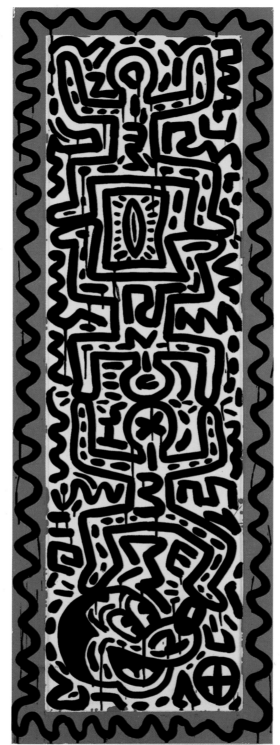

KEITH HARING

Untitled, 1982
Marker and enamel on wood
135.8 x 46.9

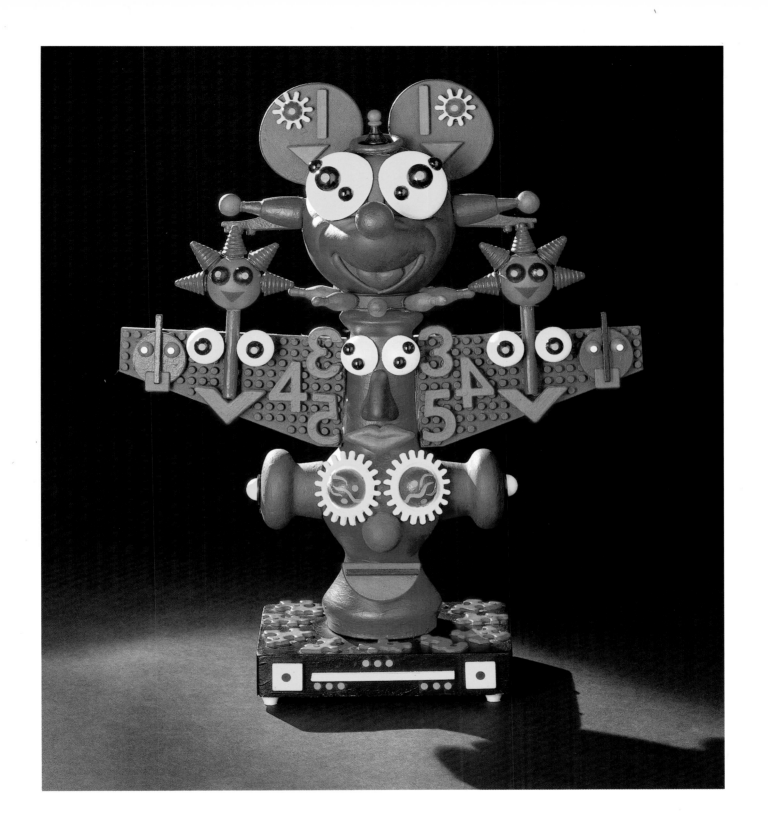

DUG MILLER

Mickey Totem, 1989
Found objects, fluorescent paint
44.5 x 37

Heiltsuk, Bella Bella
Indian Art USA 15c

Chilkat Tlingit
Indian Art USA 15c

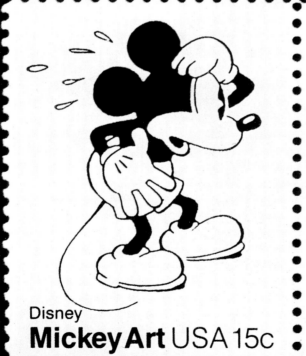

Disney
Mickey Art USA 15c

Bella Coola
Indian Art USA 15c

Stamp designs ©1980 USPS

BRADBURY THOMPSON
Mickey and the Masks, 1980-91
Mixed media
14.5 x 11.4

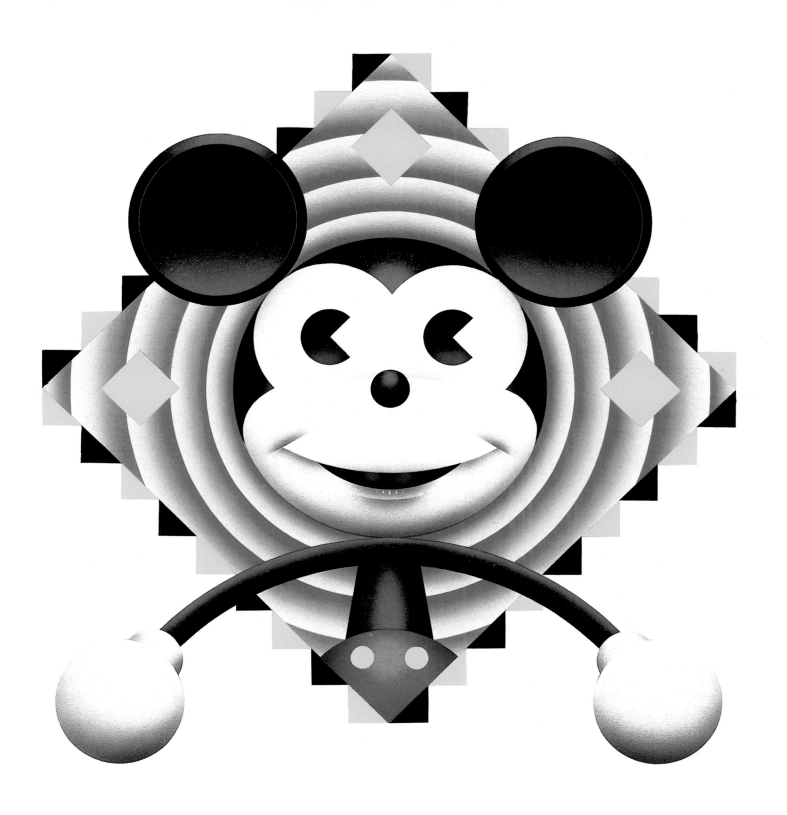

JOSÉ CRUZ
Mickey the Mouse
Acrylic
34.2 x 29

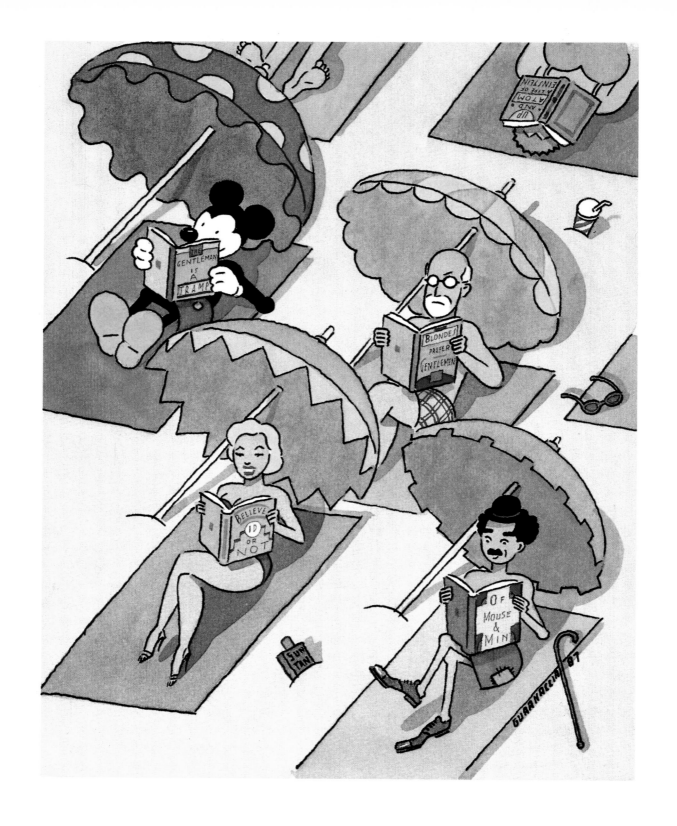

STEVEN GUARNACCIA

On the Beach, 1987
Pen and ink, water color
41.1 x 15.1

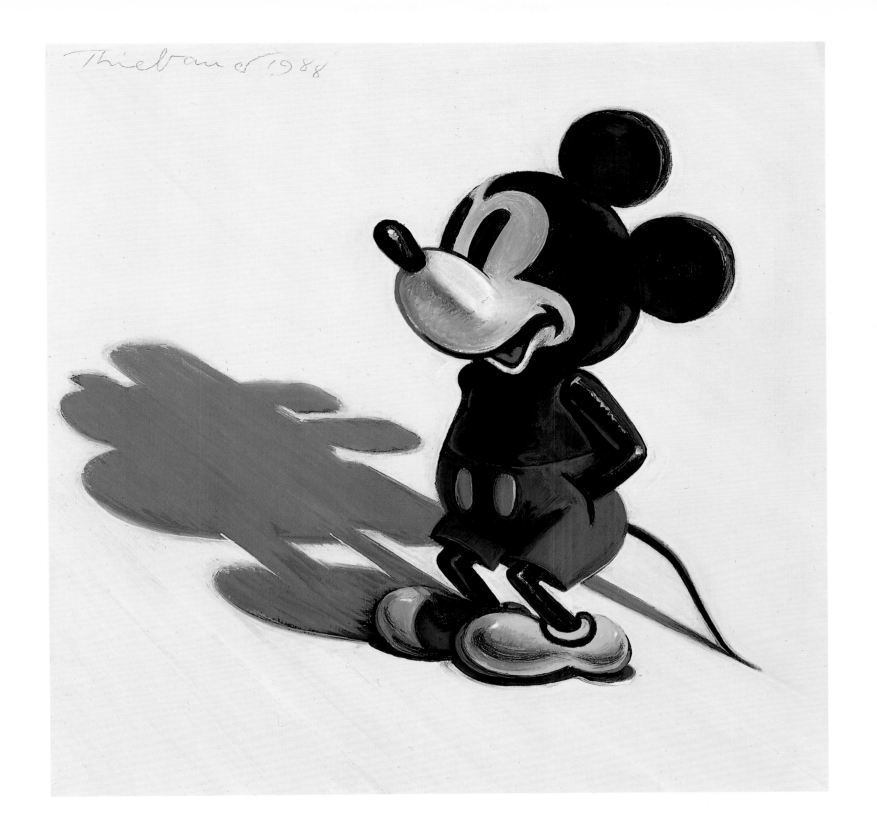

WAYNE THIEBAUD

Toy Mickey, 1988
Oil on wood
30.5 x 30.5

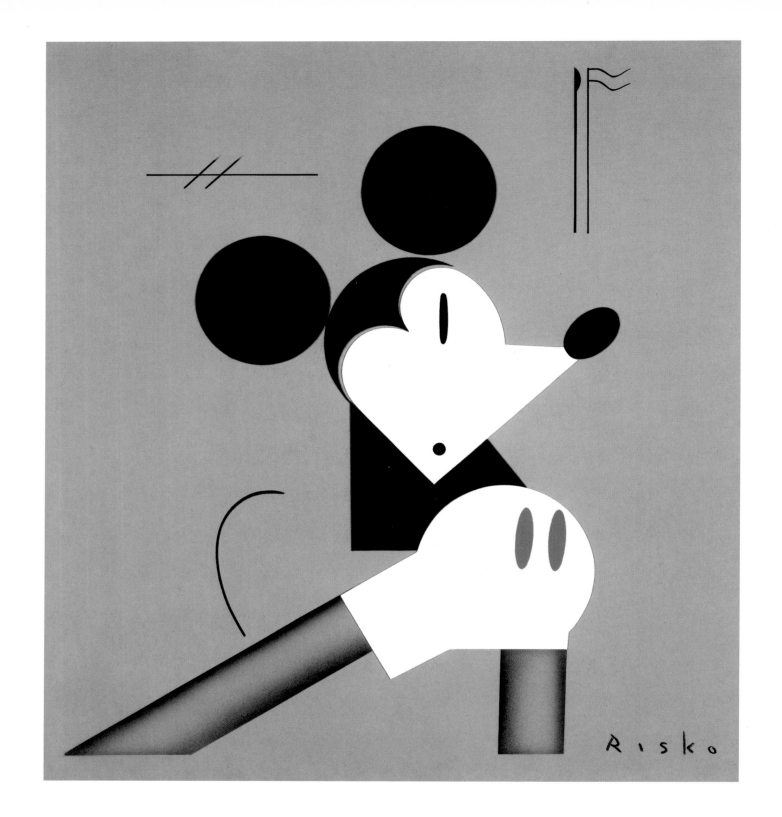

ROBERT RISKO
Minimal Mickey
Collage
50 x 37

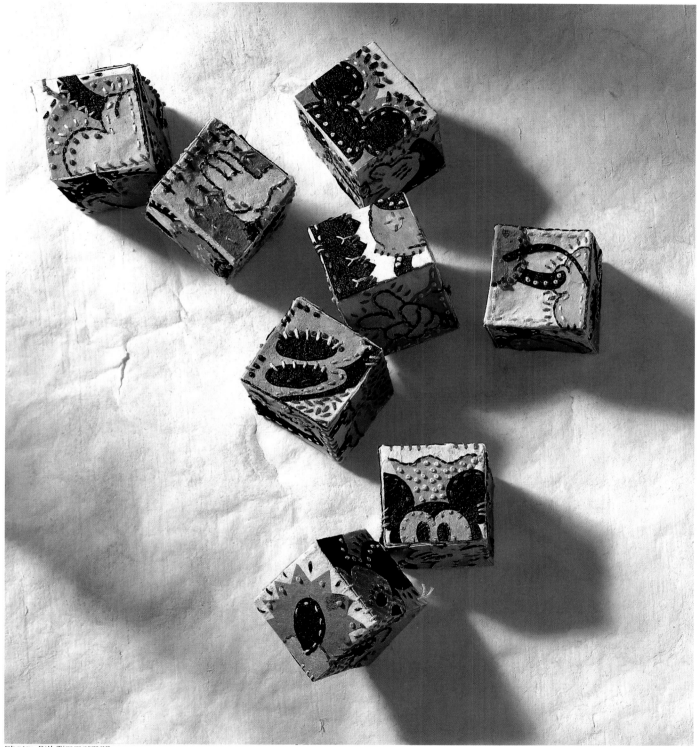

ANN MORTON HUBBARD
Mickey Mouse in 30.375
Cubic Inches (Detail)
Paper and embroidery floss
38.5 x 22

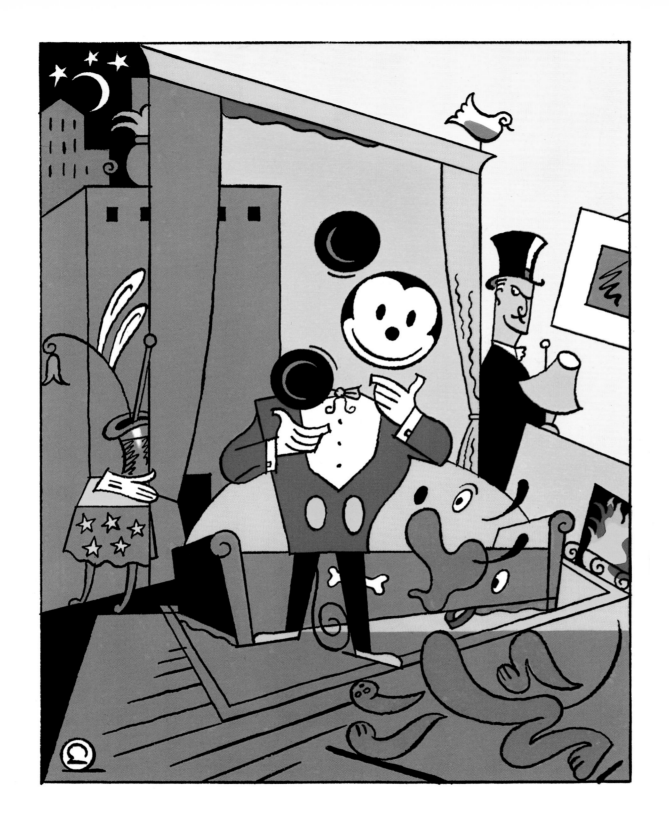

EVER MEULEN
Watch This One
Pen and ink, overlay on blue bristol
22.3 x 17.2

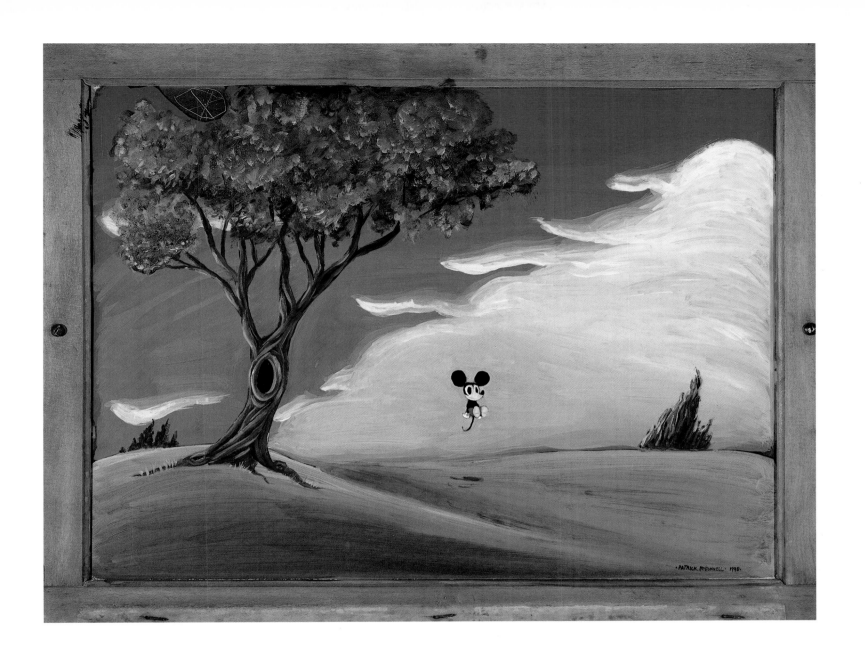

PATRICK MCDONNELL

Floating Mickey, 1990
Oil on graphite
53.4 x 63.7

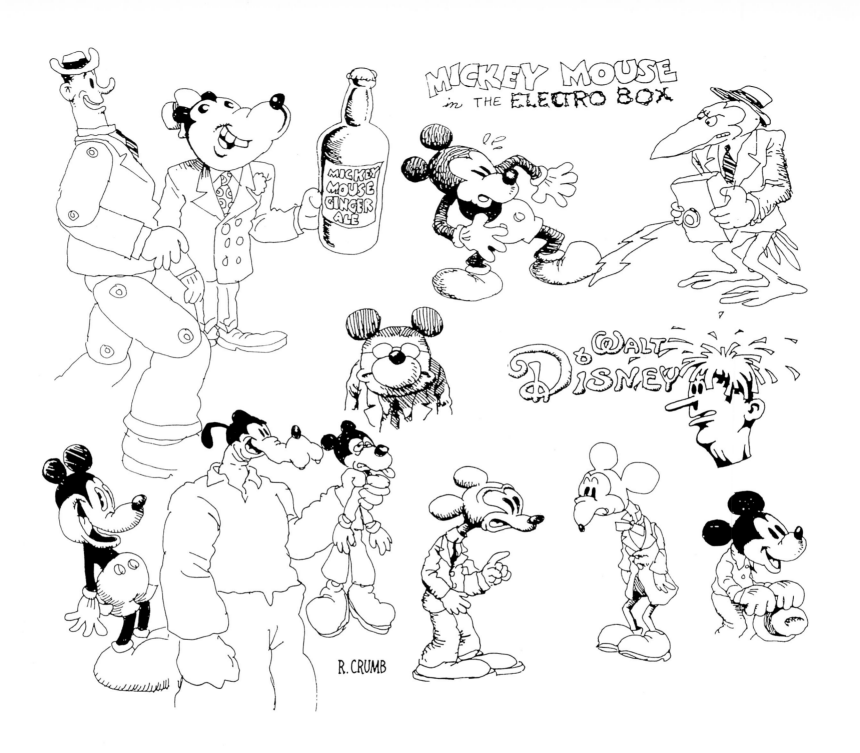

R. CRUMB
Untitled, 1966-1967
Pen and ink
Sketchbook details

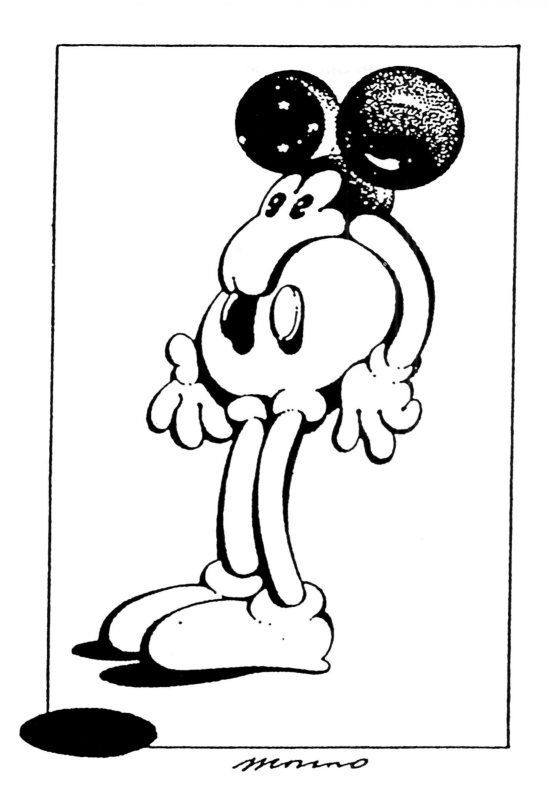

VICTOR MOSCOSO

Untitled, 1970
Pen and ink
20.3 x 15.2

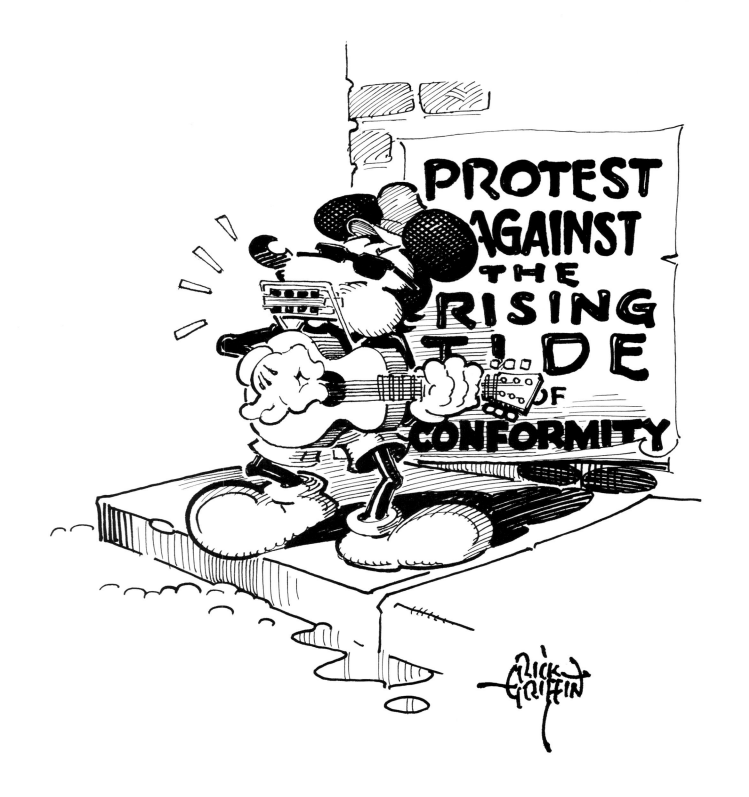

RICK GRIFFIN
Protest
Pen and ink
43 x 35

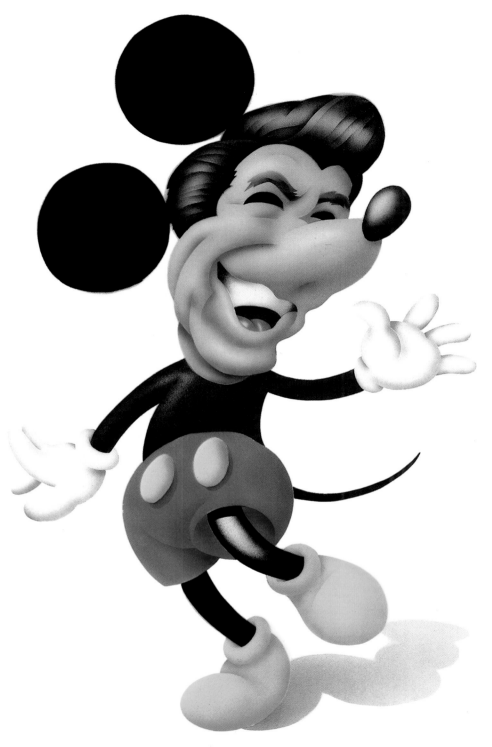

ROBERT GROSSMAN
Ronald Reagan, 1967
Water color
50.7 x 38.1

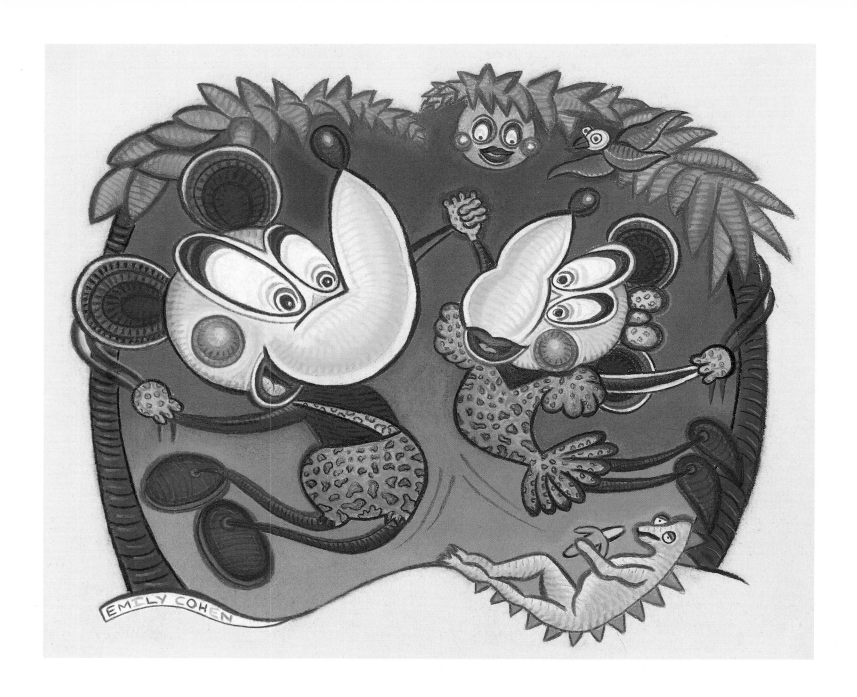

EMILY COHEN
Me Mickey, You Minnie
Pastel
28 x 30.5

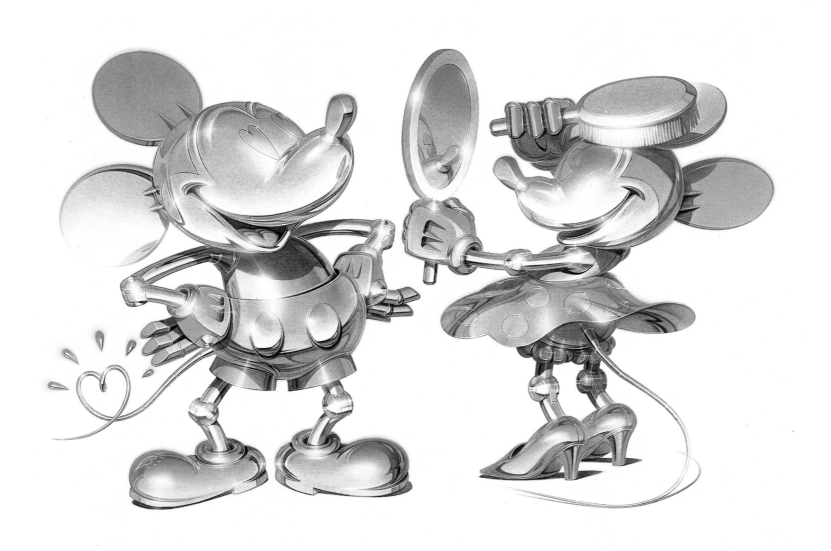

HAJIME SORAYAMA
Untitled
Acrylic on board
51.5 x 36.4

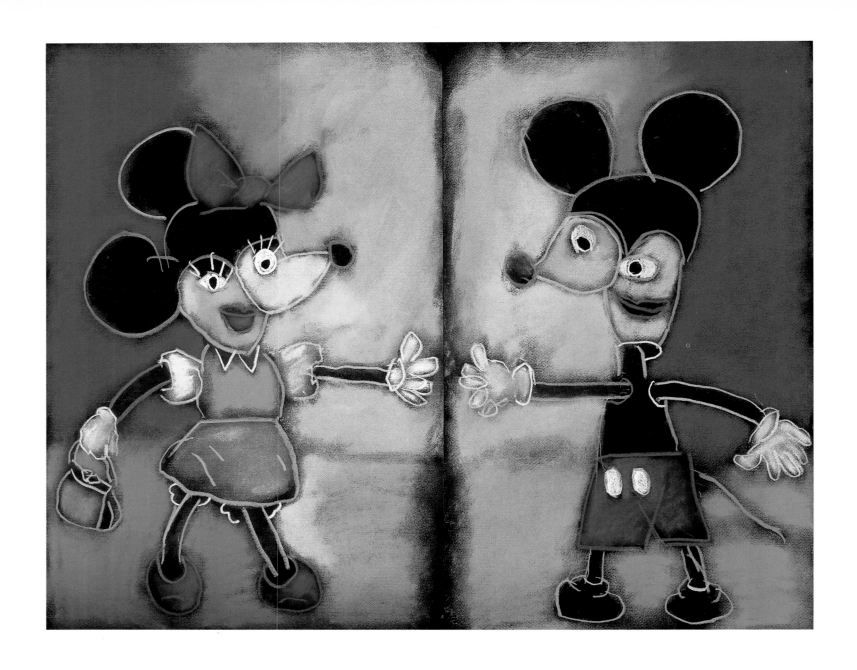

ANDRZEJ DUDZINSKI
The Mouses
Oil crayon & pastel on paper
Diptych
70.6 x 45.4

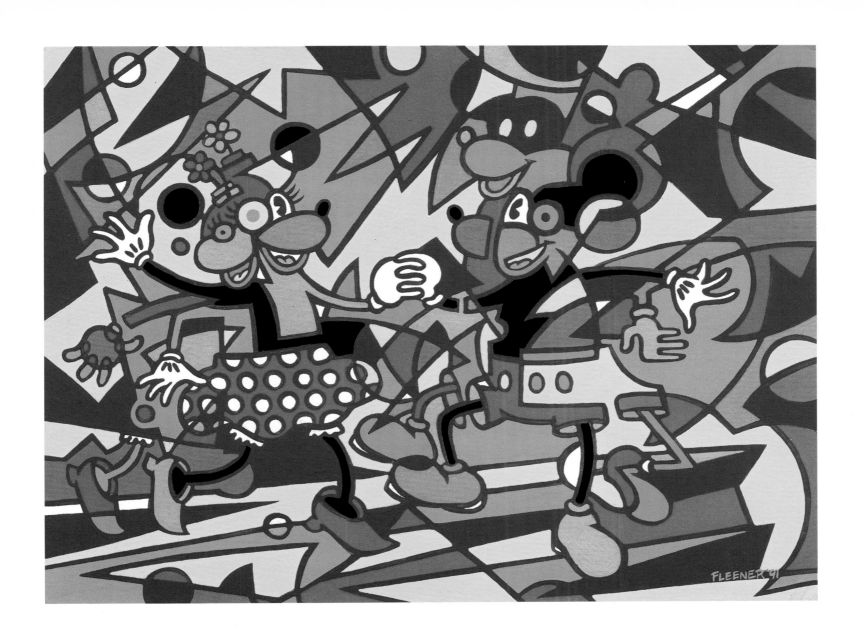

MARY FLEENER
Mickey's Boogie
Acrylic on canvas
45.7 x 60.9

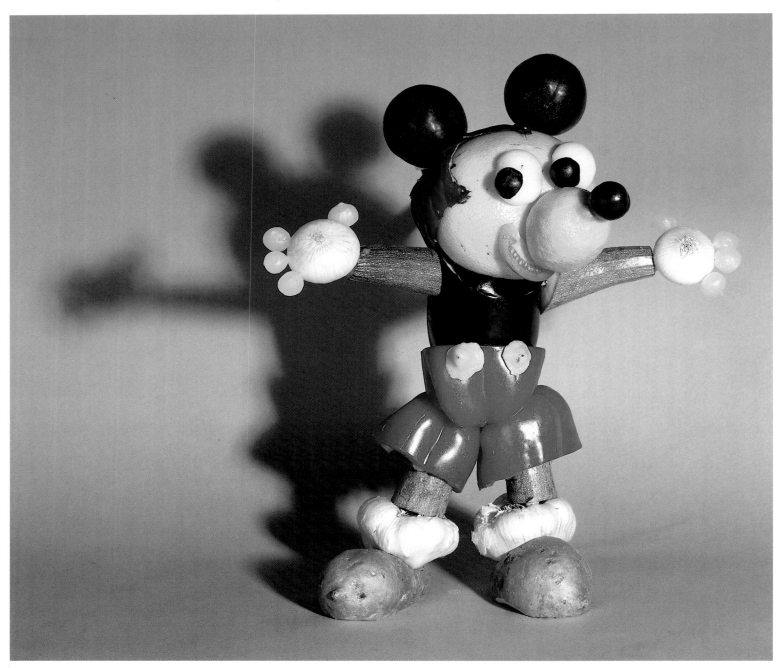

Photo: Gerald Janssen

ADAM KURTZMAN
Mickey's Salad Days
Fruit and vegetables
50 x 38 x 22

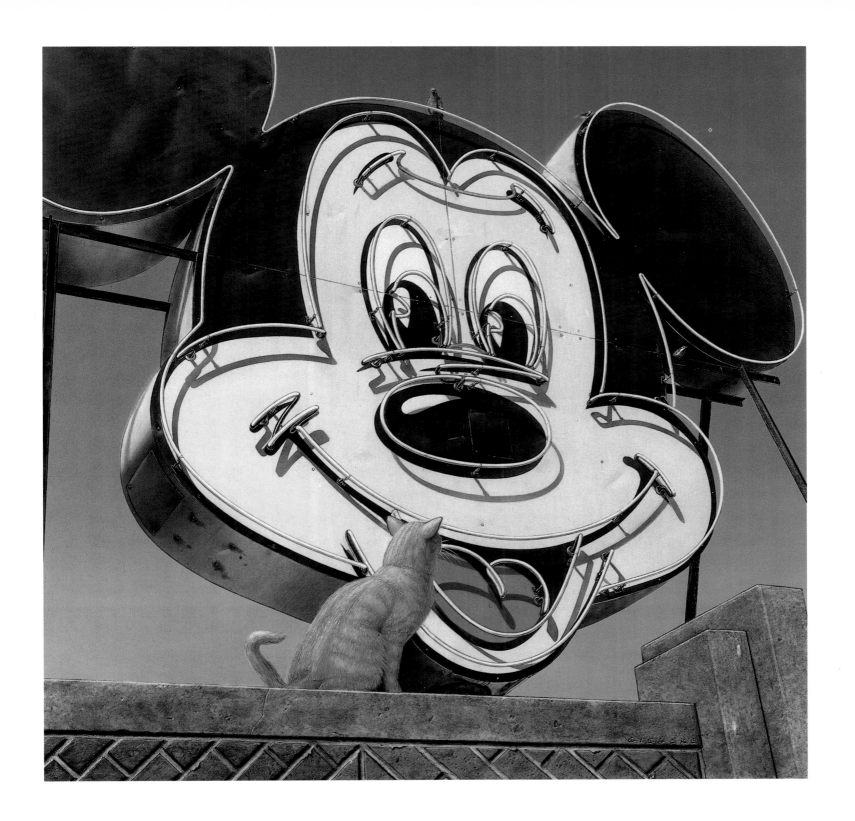

THOMAS GIESEKE
Cat and Mouse
Mixed media
48.5 x 48.5

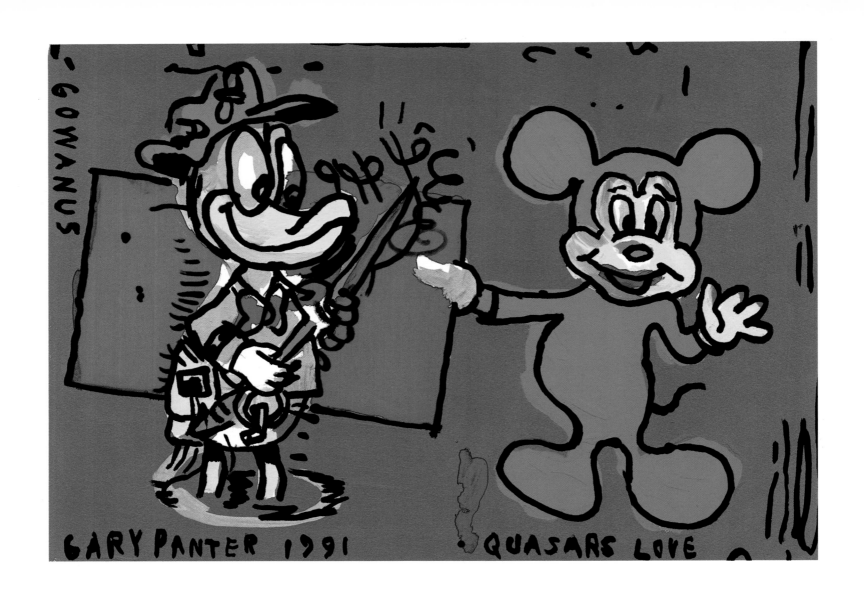

GARY PANTER
Quasars Love
Acrylic on paper
35.5 x 50.5

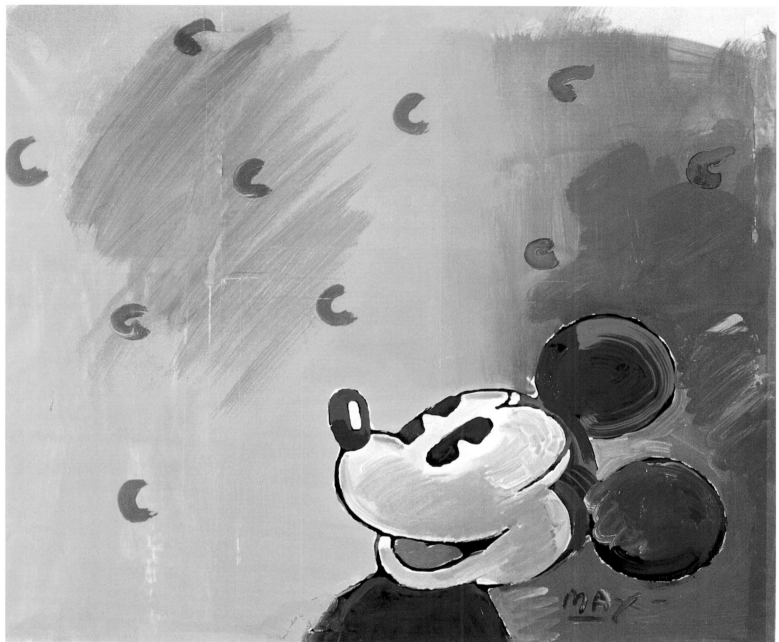

PETER MAX

Mickey Mouse
Acrylic on paper
52.1 x 60.9

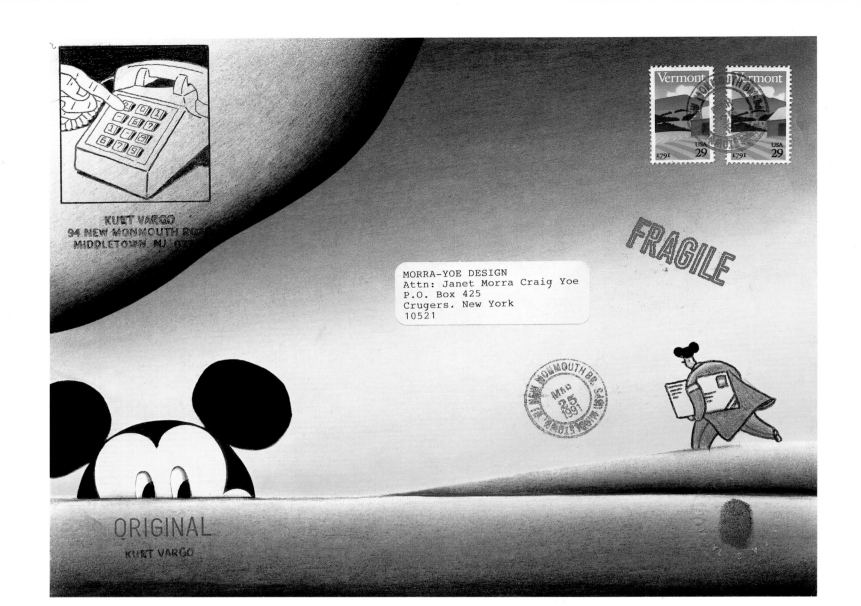

KURT VARGO
Missive to Mickey
Pastels and rubber stamps
22.8 x 30.3

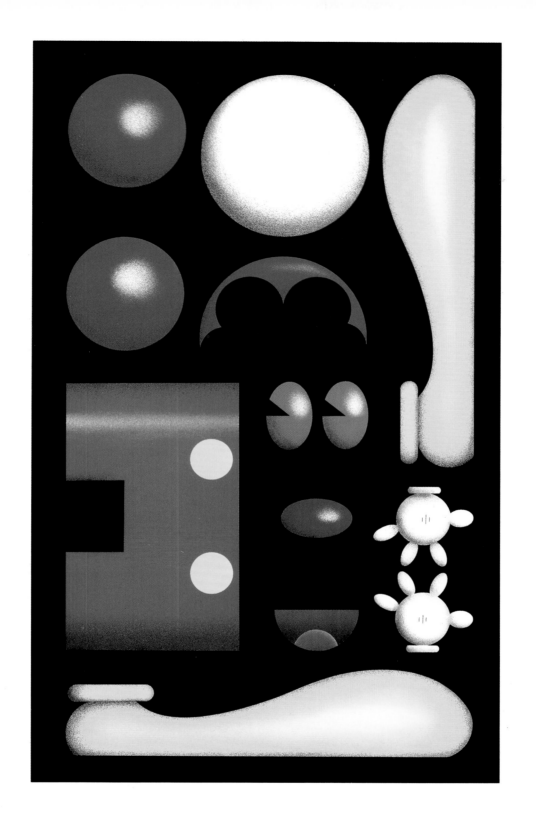

TERRY ALLEN
Meese's Pieces
Gouache
63.6 X 42.1

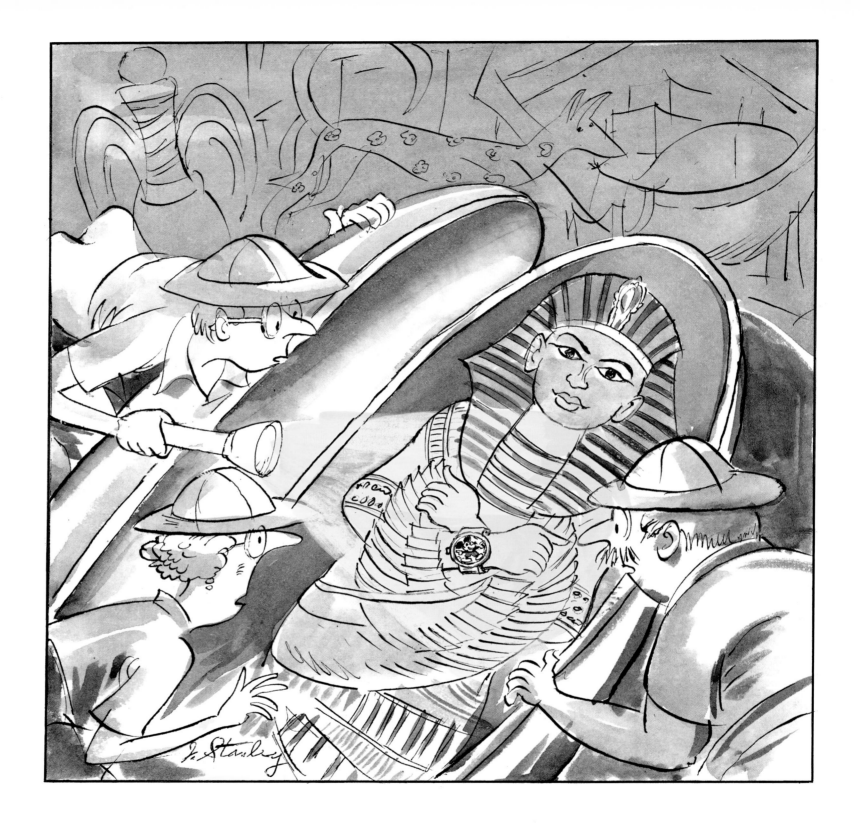

JOHN STANLEY
*The Fabulous Treasure
of King Tutankhamun*
Ink and watercolor
26.7 x 26.7

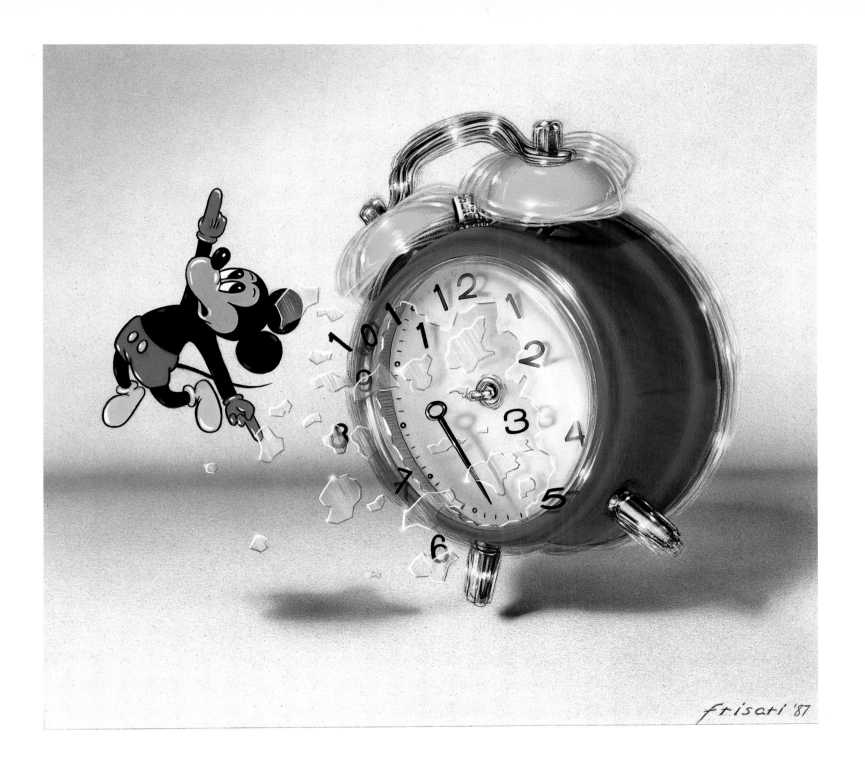

FRANK FRISARI
Mickey Takes a Lickin', 1987
Acrylic on illustration board
23 x 25.5

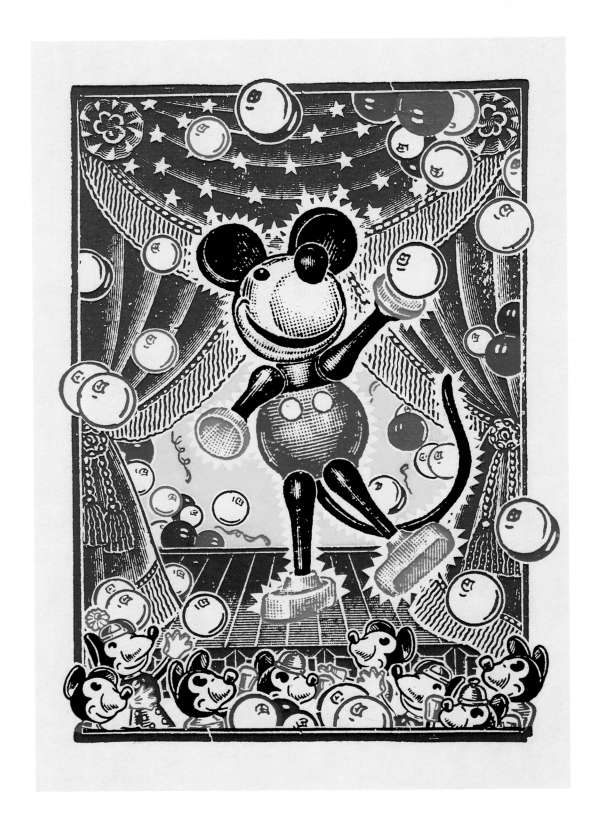

JOHN CRAIG
Mickey Shares His Thoughts
Collage and overlays
24.2 X 17.8

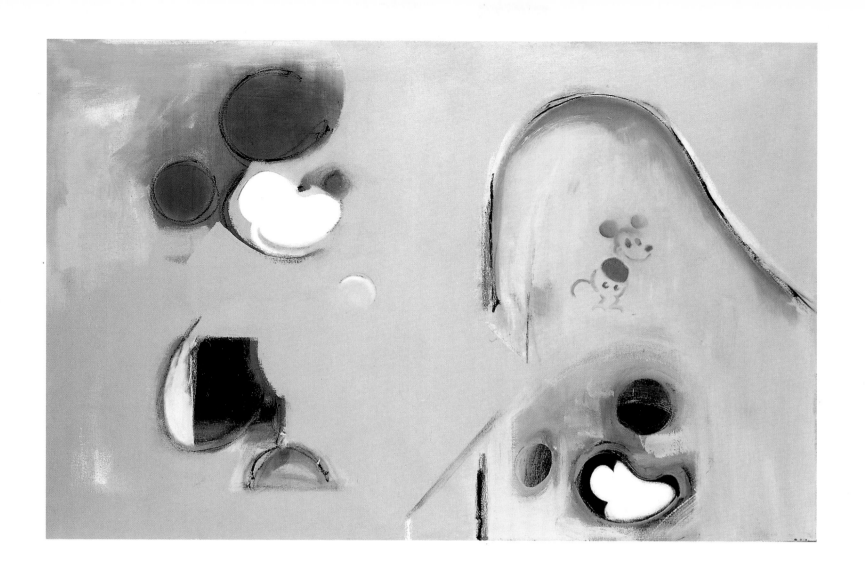

PATRICK MCDONNELL

Mickey Mouse Painting, 1990
Oil, acrylic, latex
101.6 x 152.4

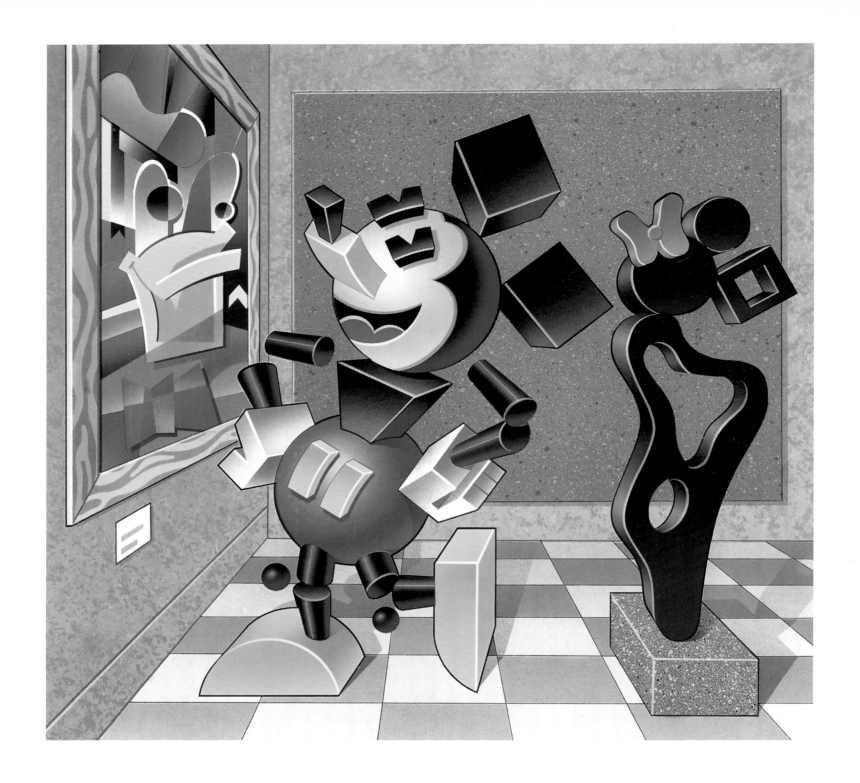

DAVE JONASON
Mickey in the Museum
Acrylic
33 x 35

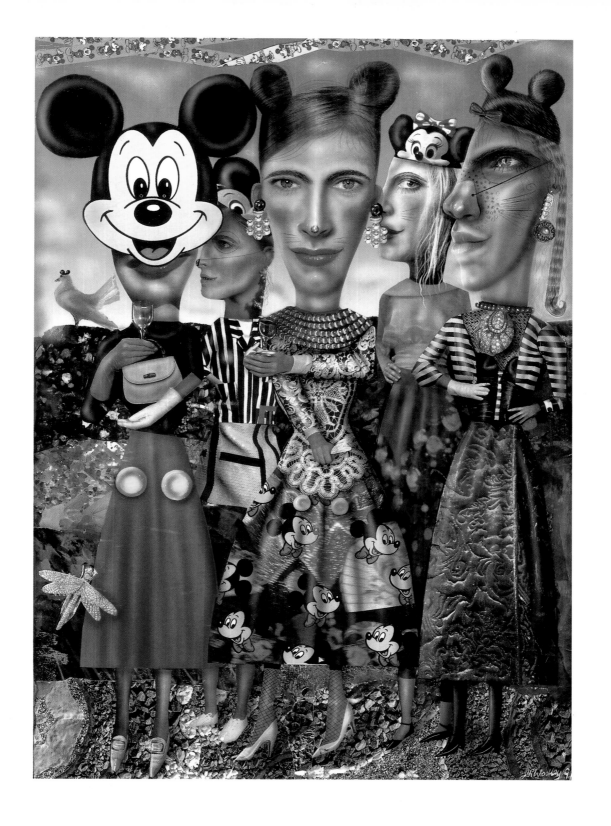

JANET WOOLLEY
Mickey Mouse Fancy Dress
Collage and acrylic
60 x 42

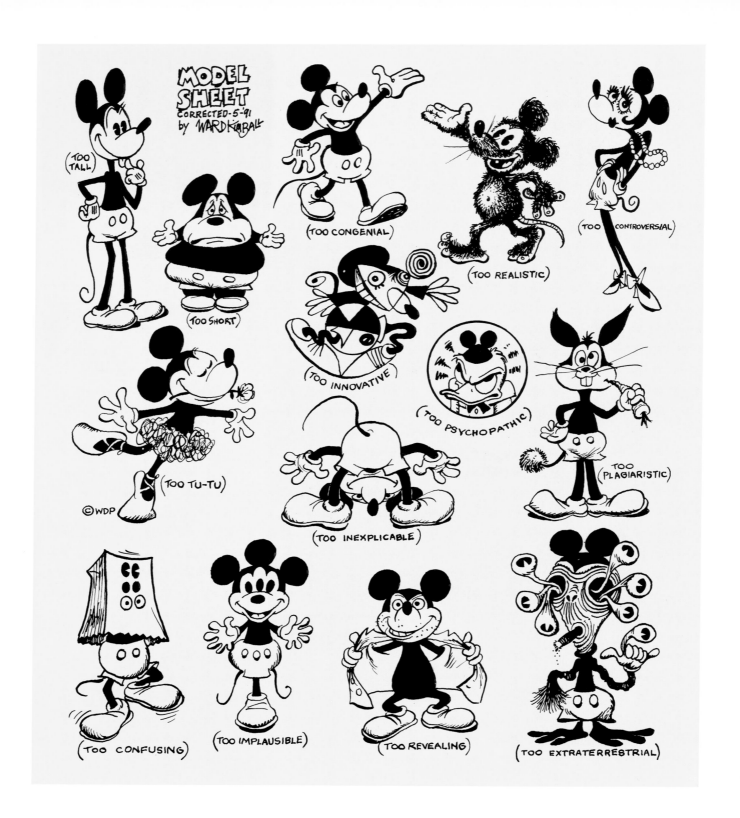

WARD KIMBALL
Model Sheet, 1985-91
Pen and ink
31.2 x 26

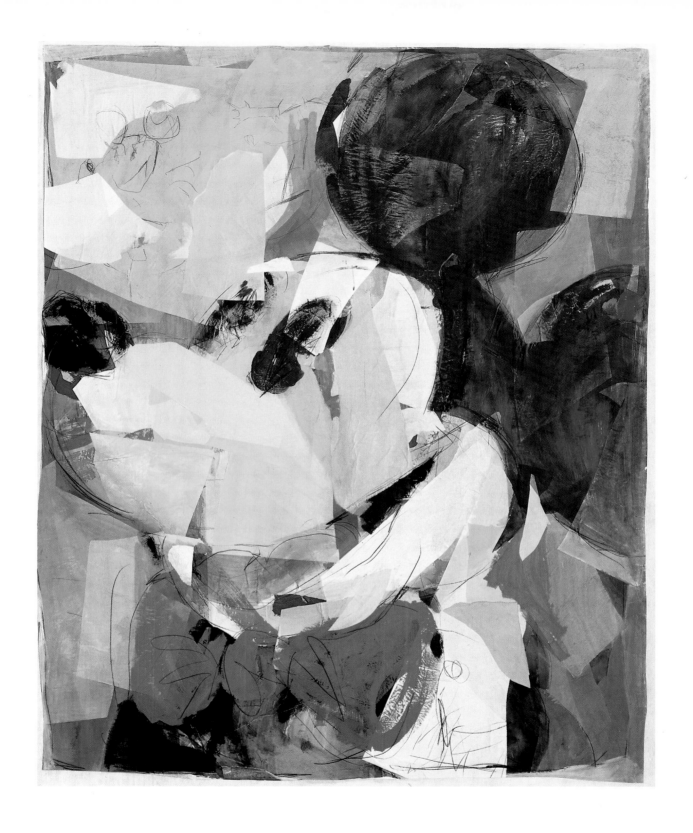

KATSUYA ISE

Mickey Mouse, 1985
Acrylic and paper on canvas
160 x 130

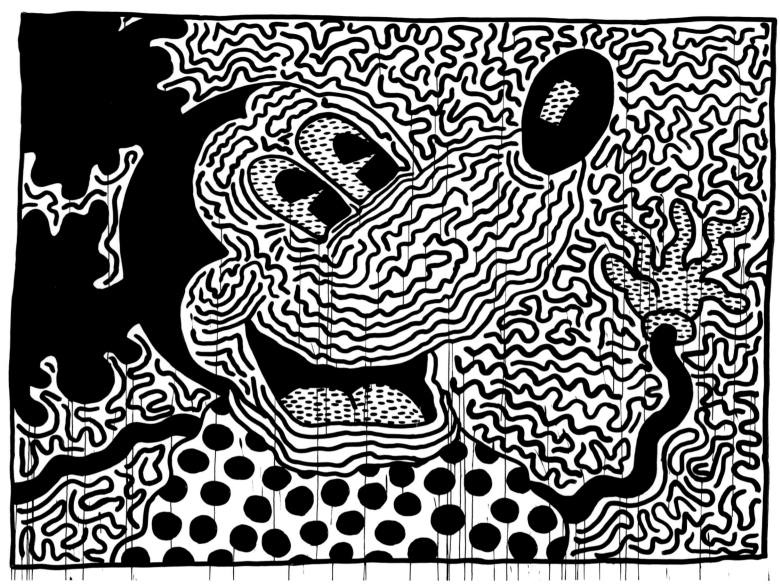

KEITH HARING

Untitled, 1982
Sumi ink on paper
182.9 x 238.2

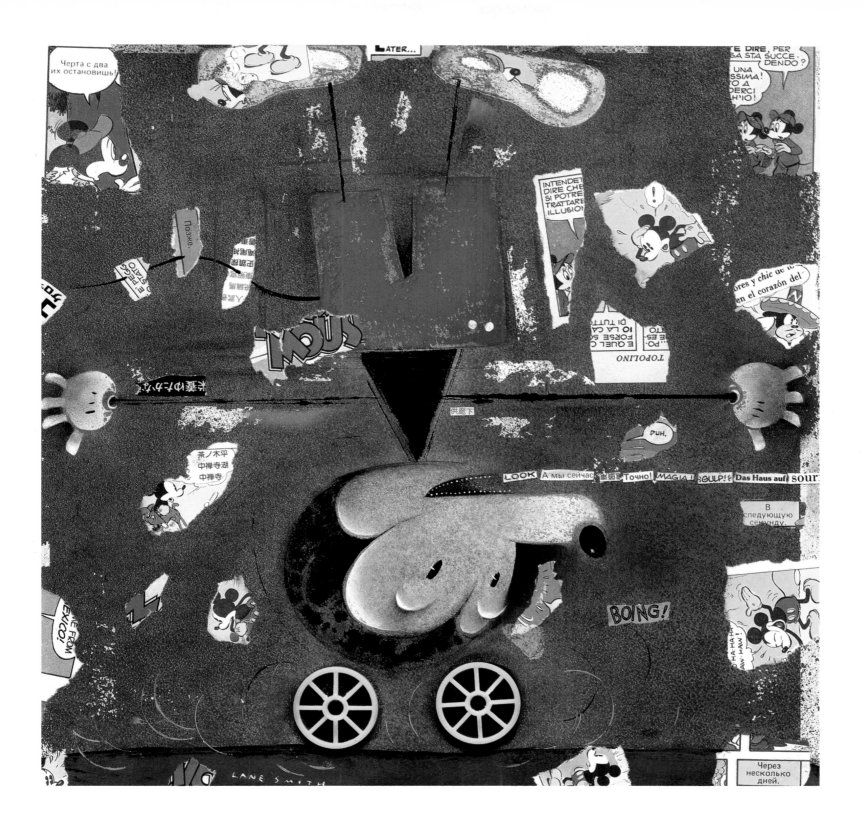

LANE SMITH
Mickey Machine
Mixed media
27 x 27

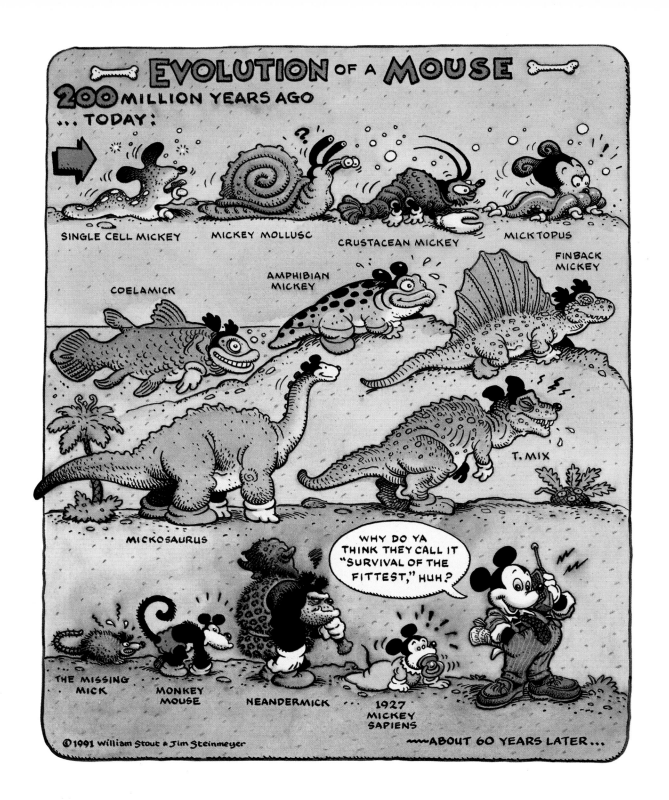

WILLIAM STOUT
JIM STEINMEYER
Evolution of a Mouse
Pen and ink, water color
34.3 x 27.3

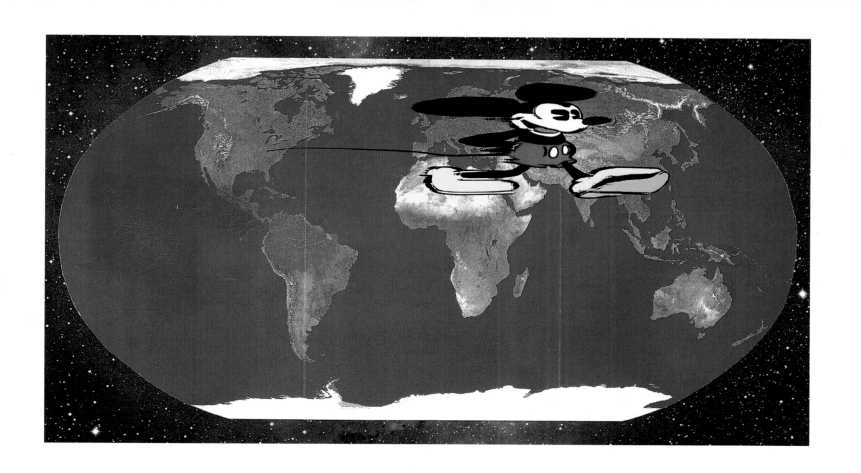

FRANK OLINSKY

Truckin'
Mixed media
21 x 37.8

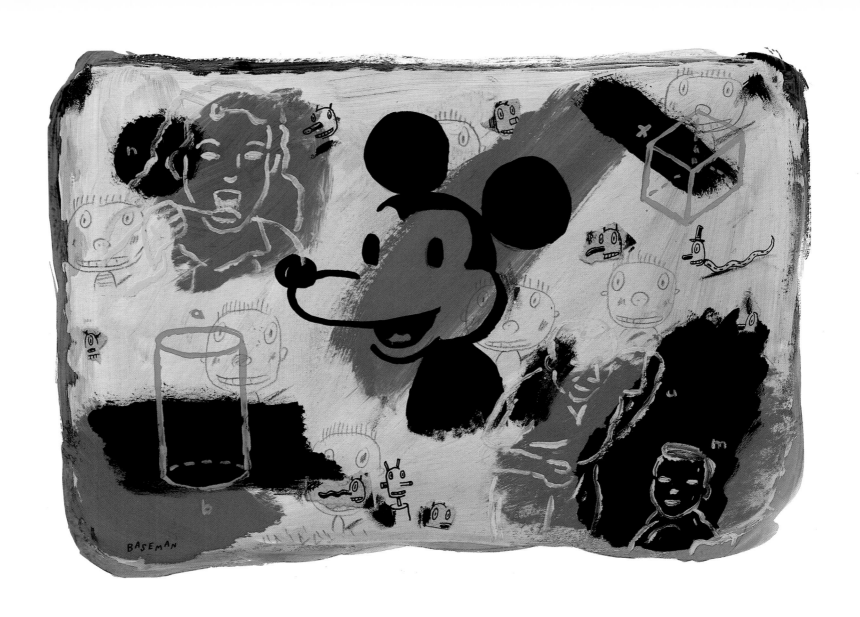

GARY BASEMAN
First Haircut
Mixed media
27.5 x 38

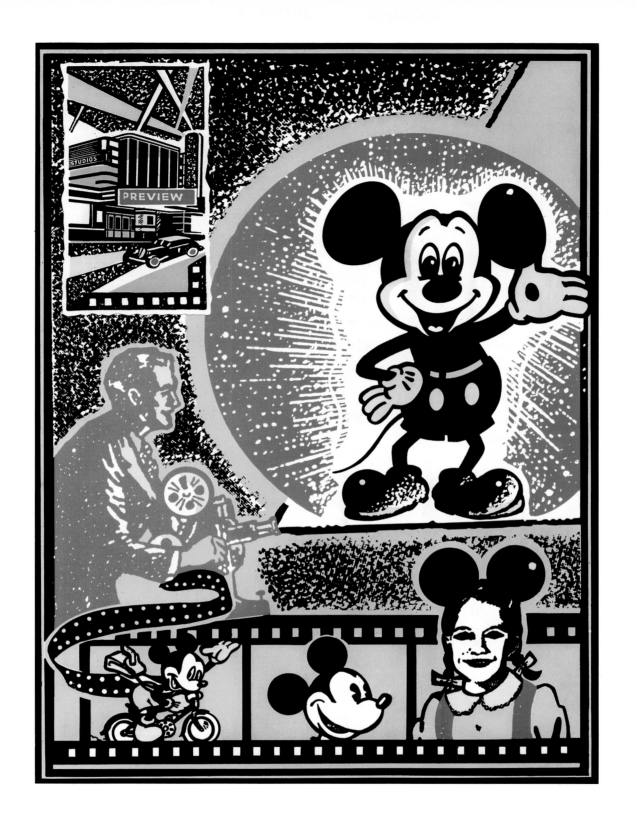

CHRIS SPOLLEN
A Day in the Life of Mickey
Letrachrome print
38.2 x 28.2

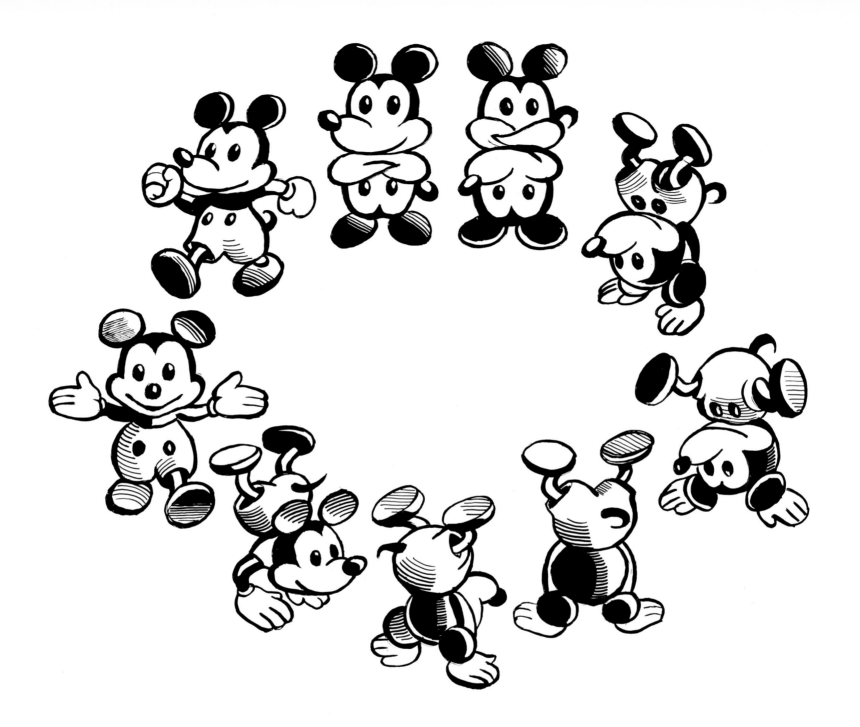

DAVID SUTER
Untitled
Pen and ink
35.5 x 40

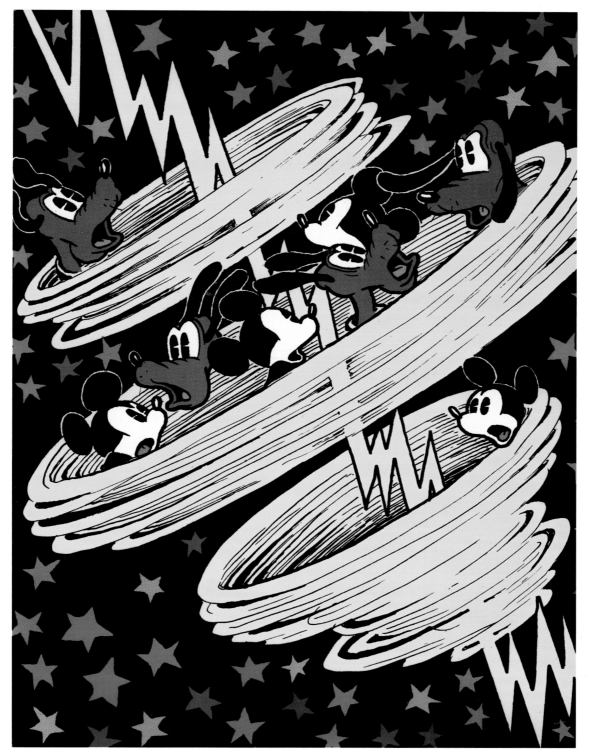

Special thanks to Bill Spicer, Glenn Bray and Monte Wolverton

BASIL WOLVERTON

Untitled, c. 1935
Pen and ink
15.3 x 14.6

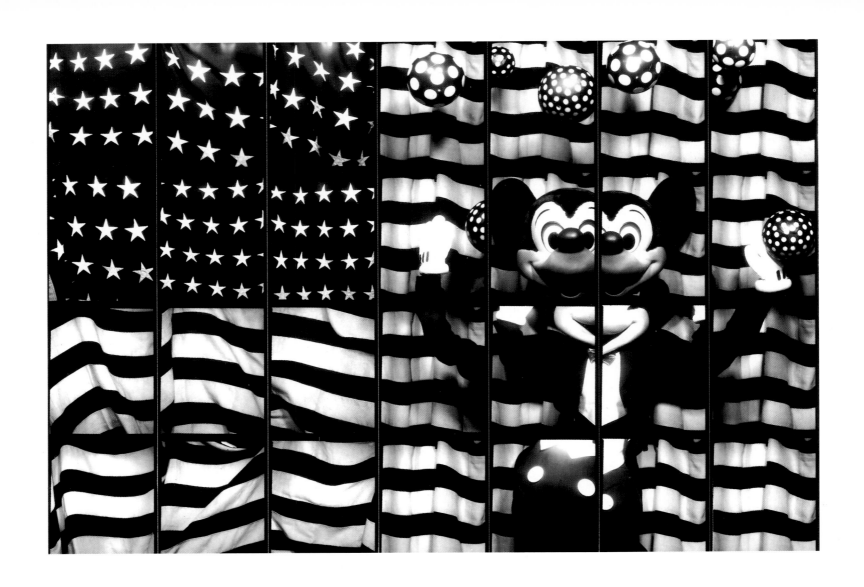

HERMAN COSTA
Mickey Plays Ball:
Stars and Stripes Version
7 uncut (4-frame) B&W photobooth strips
20.4 x 28.3

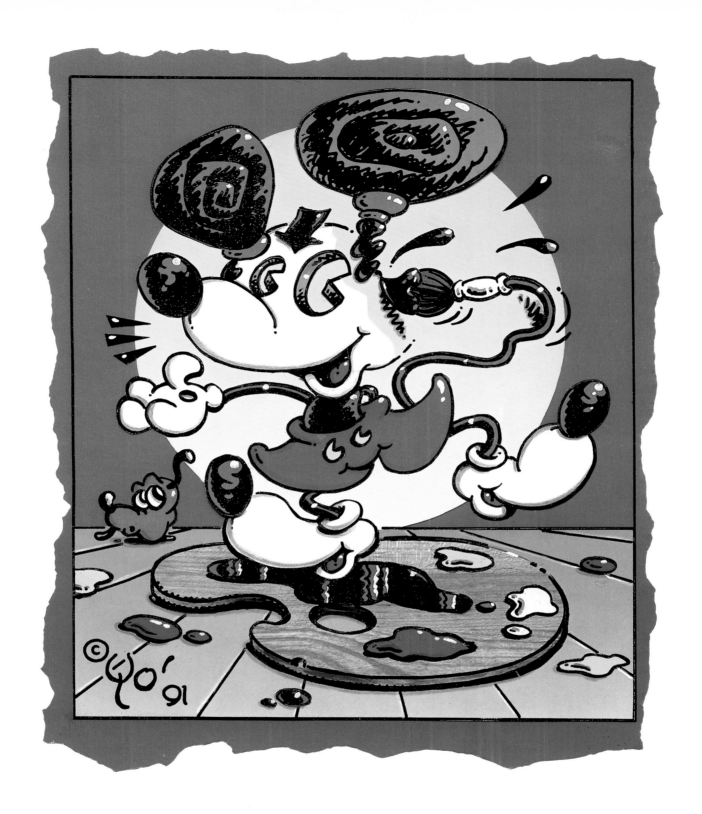

CRAIG YOE
Self Portrait
Mixed media
38 x 33

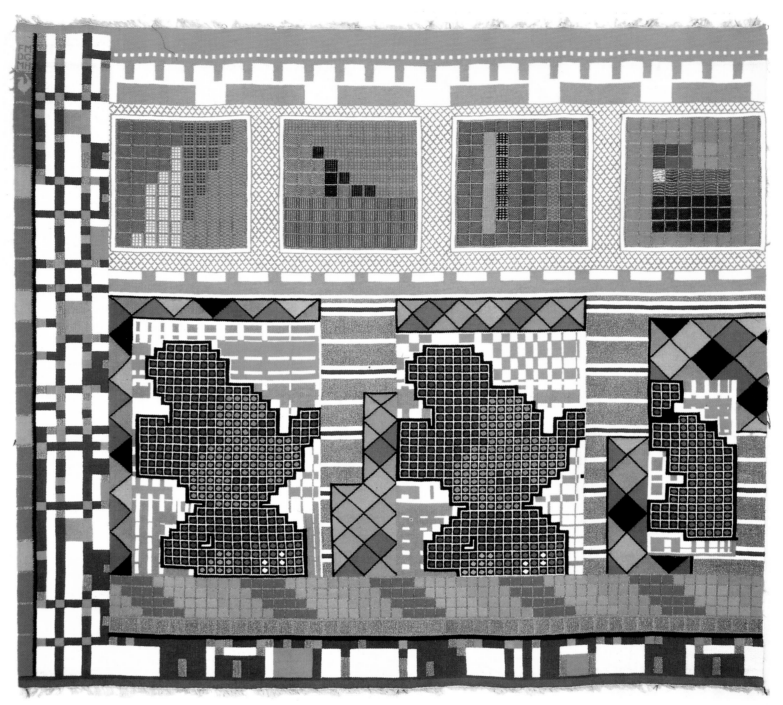

SIR EDUARDO PAOLOZZI
DIRECTOR OF WEAVING: ARCHIE BRENNAN
WEAVERS: FRED MANN, HARRY WRIGHT,
DOUGLAS GRIERSON AND MAUREEN HODGE
The Whitworth Tapestry, 1967
152.3 x 172.8

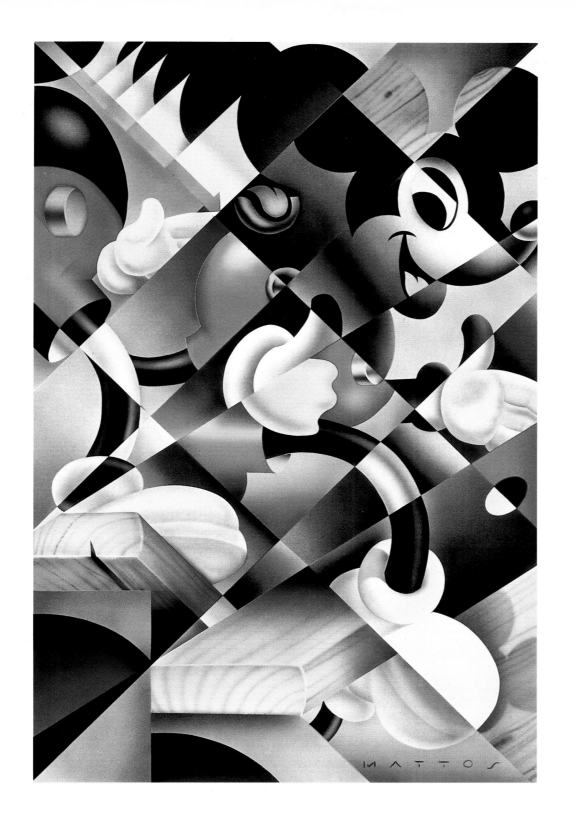

JOHN MATTOS
*Mickey Descending
a Staircase,* 1988
Ink
43.2 x 28

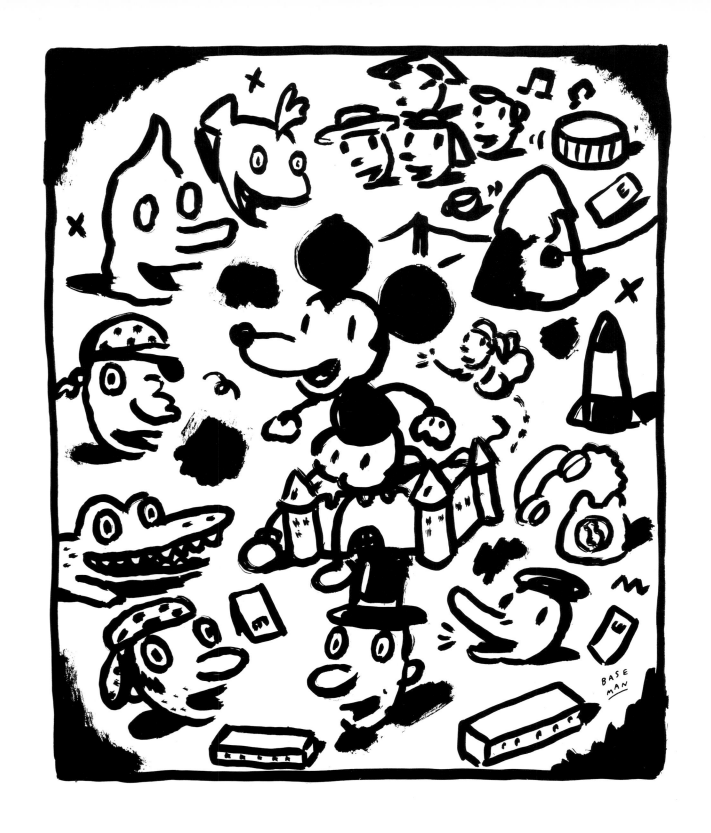

GARY BASEMAN
Disneyland from Left to Right
Ink
42.5 x 35.5

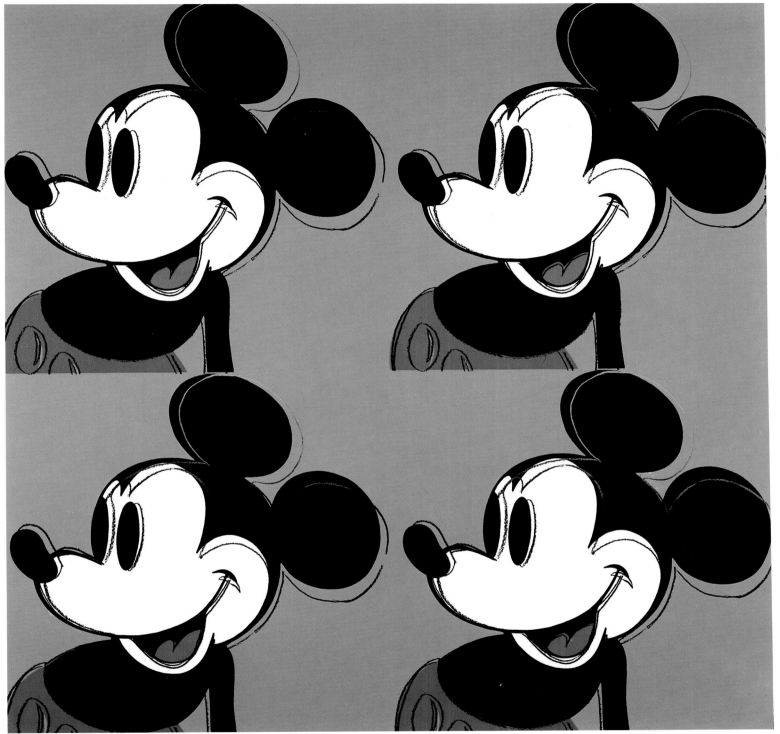

ANDY WARHOL

Mickey Mouse (Myths Series), 1981
Silkscreen ink on synthetic polymer
paint on canvas
152.4 x 152.4

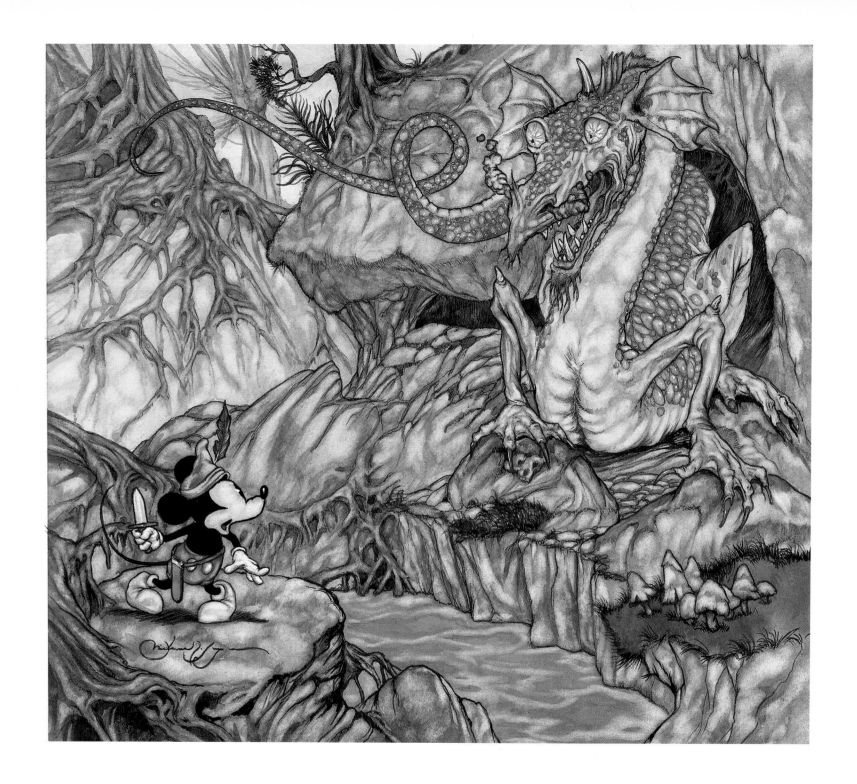

MICHAEL R. HAGUE
Mickey, the Dragon Slayer
Water color
28 x 28

HEINZ EDELMANN
Untitled
Mixed media
20.5 x 14.6

HEINZ EDELMANN
Untitled
Mixed media
20.5 x 14.6

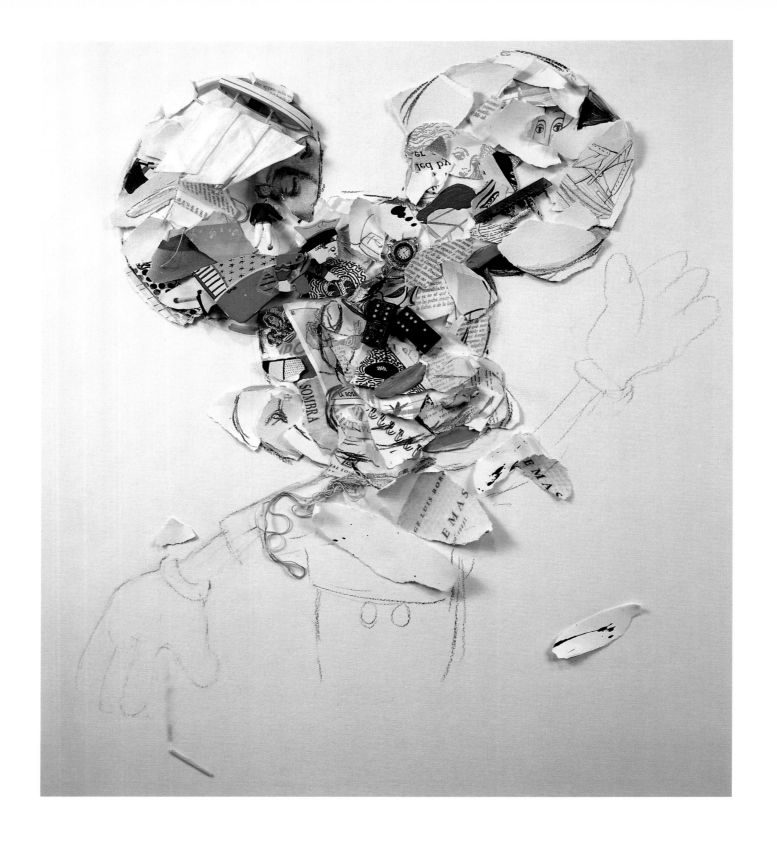

LILIANA PORTER
El Raton Mickey (Detail), 1990
Mixed media collage
106.7 x 76.2

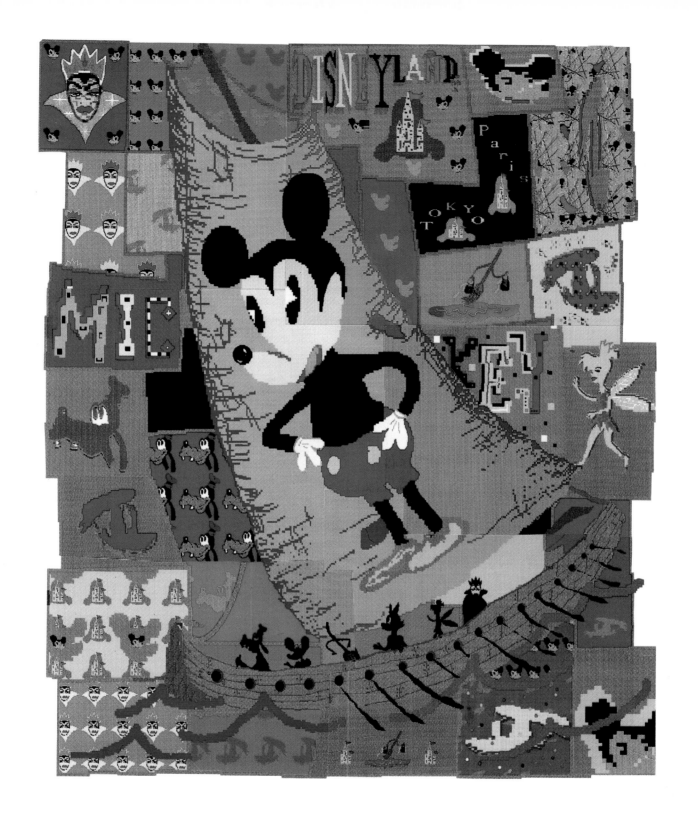

GEORGANNE DEEN
Mickey Mouse
Ink jet print
61.4 x 50.6

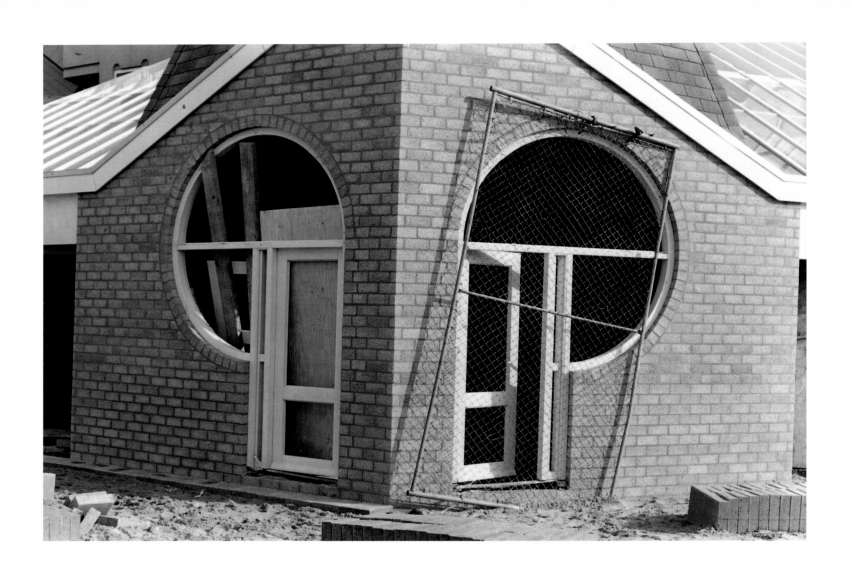

WILLEM DE BOER
Mickey Mouse Building, 1989
Photo
17 x 25.5

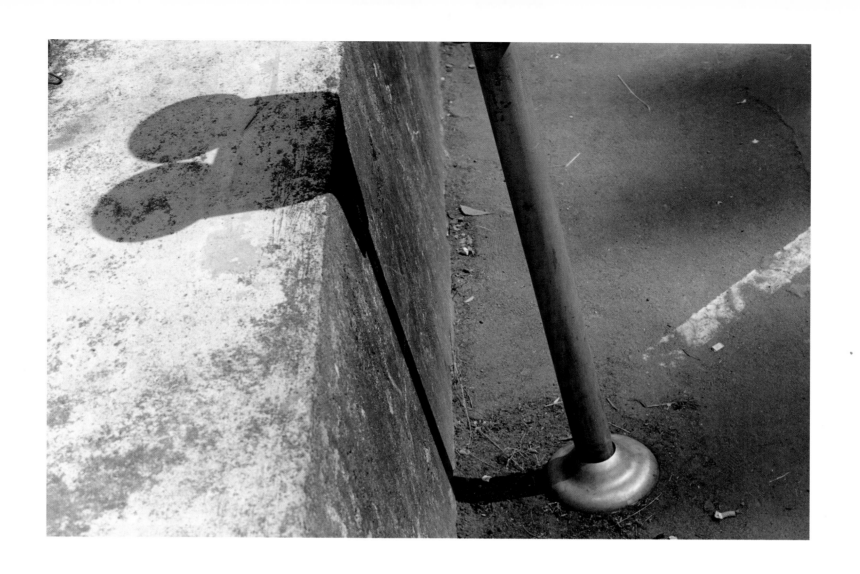

WILLEM DE BOER
Mickey Mouse Parking Meter, 1980
Photo
17 x 25.5

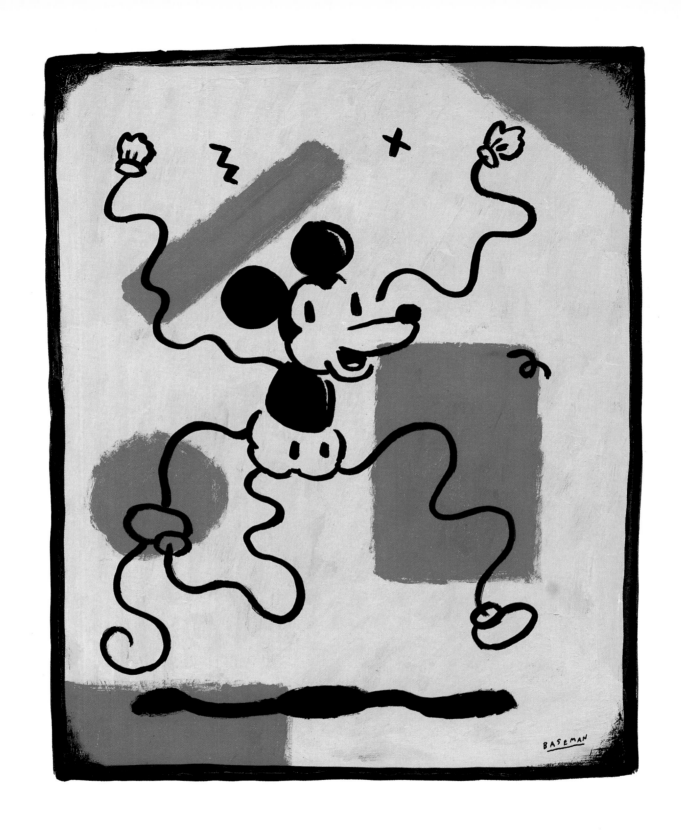

GARY BASEMAN
Rubber Legs Mickey
Ink and acrylic
51 x 41

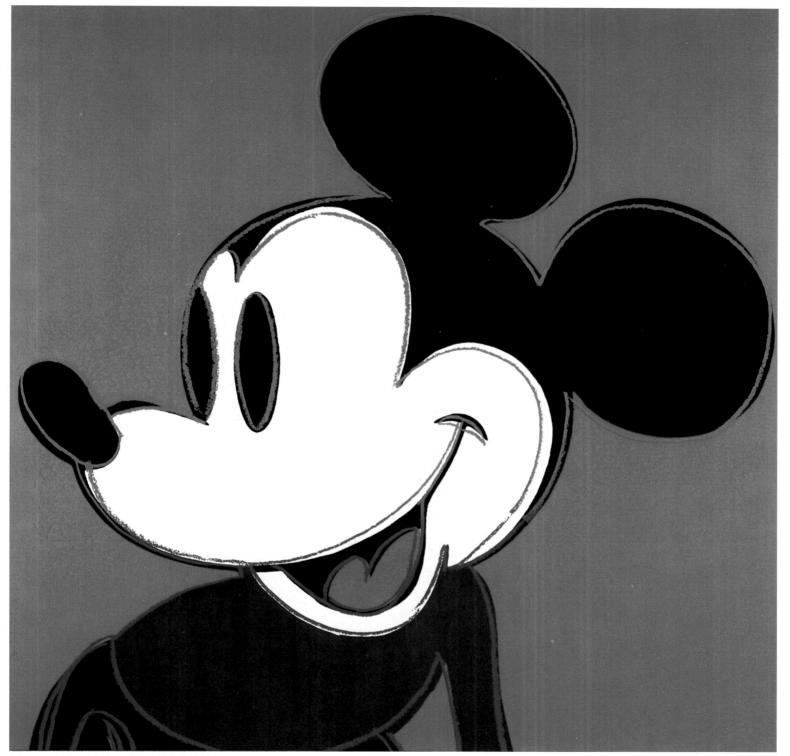

ANDY WARHOL

Mickey Mouse (Myths Series), 1981
Silkscreen ink on synthetic polymer
paint on canvas
152.4 x 152.4

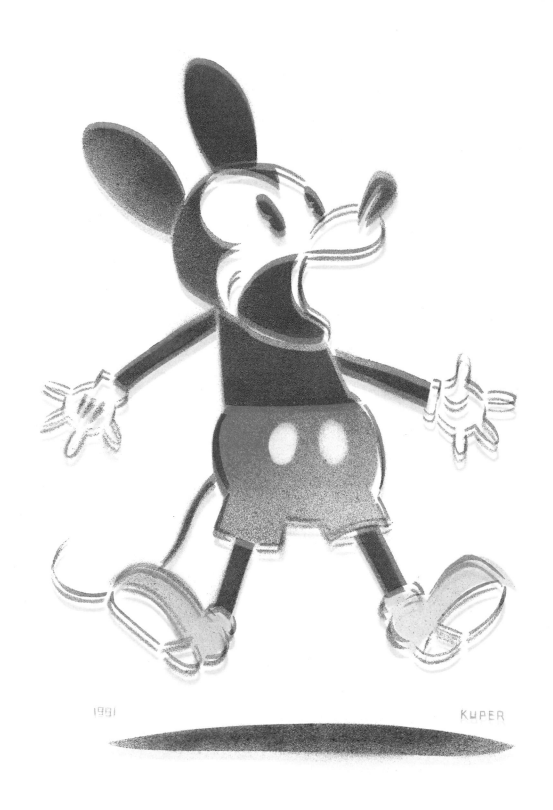

PETER KUPER
#@S&!
Stencil with enamel paint
42.5 x 35.5

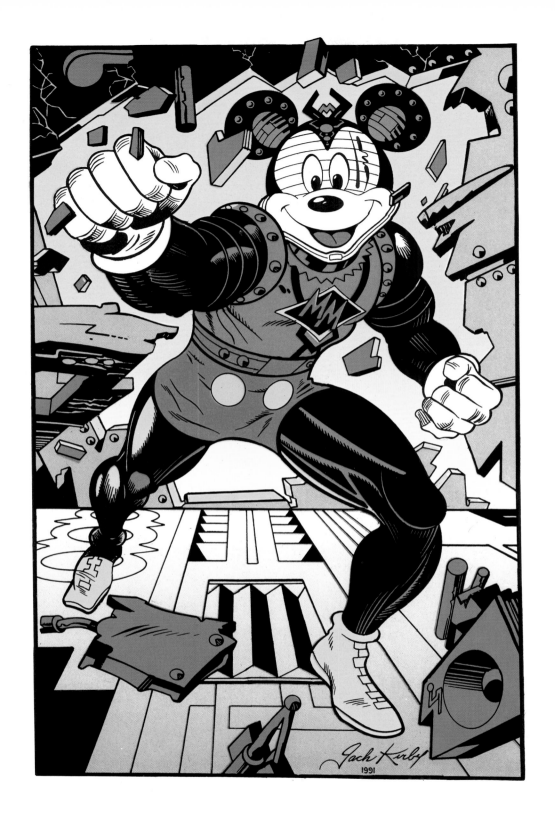

JACK KIRBY

INKER: MICHAEL E. THIBODEAUX
COLORIST: CRAIG YOE
Muscle Mouse
Ink, hand separated color
40.2 x 25.5

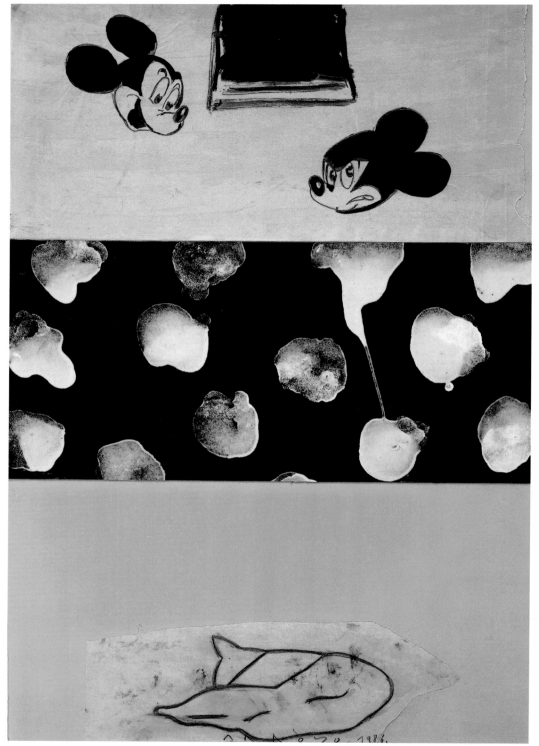

Courtesu: Galerie Berggruen, Paris Photo: Francois Poivret

EDUARDO ARROYO

Mickey, 1986
Collage and painting
44 x 29.5

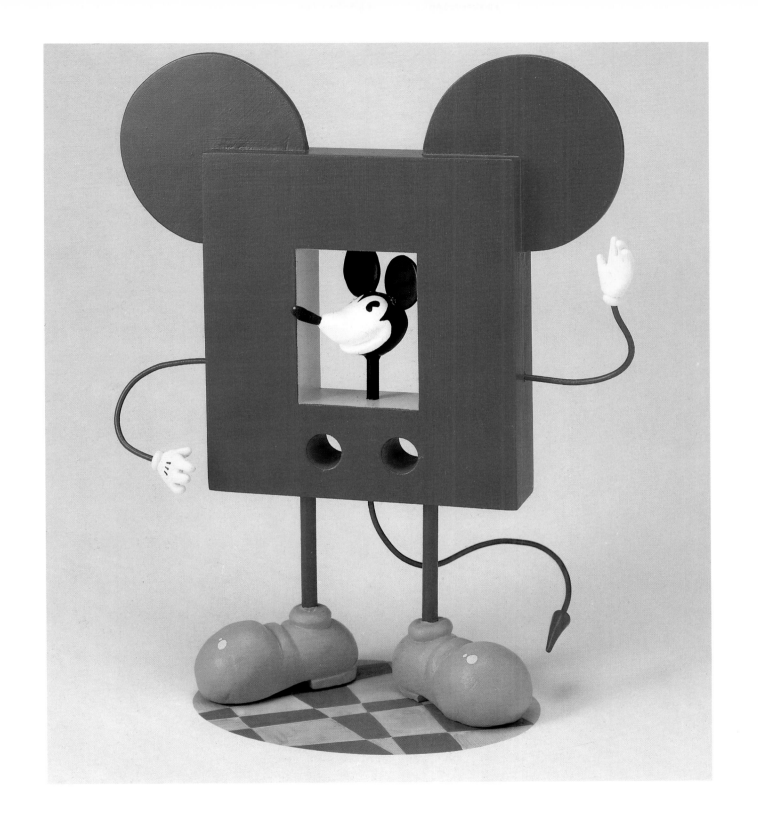

DAVE CALVER
Standing Mickey #1
Mixed media
30.5 x 20.4 x 10.2

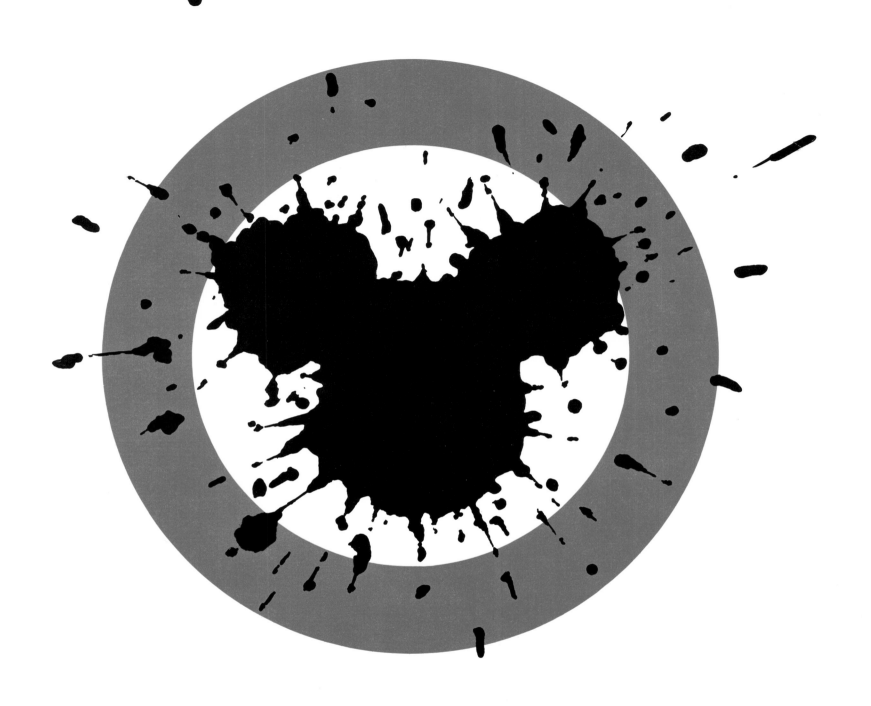

MIKE FINK
Minky Mouse, 1983
Ink and overlay
5 x 5

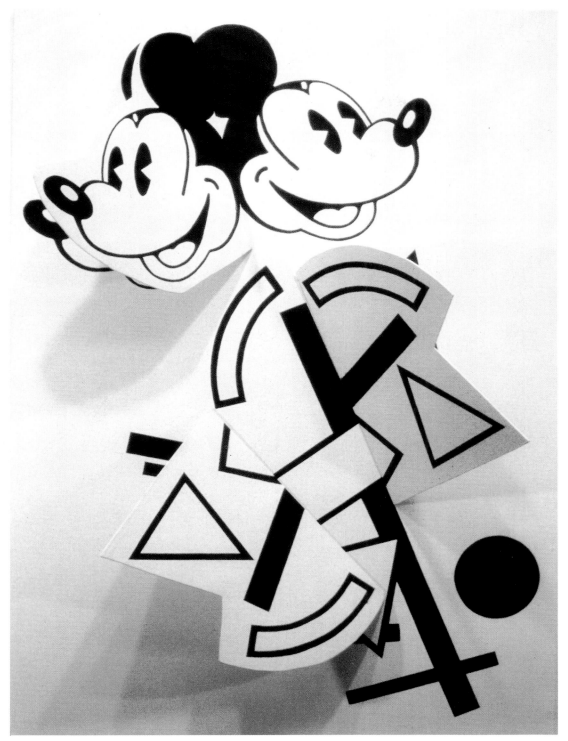

Courtesy the Ruth Siegel Gallery, New York.

ALEXANDER KOSOLAPOV
Mickey-Lissitzky, 1986
Acrylic on canvas, board
167.6 x 121.9 x 45.7

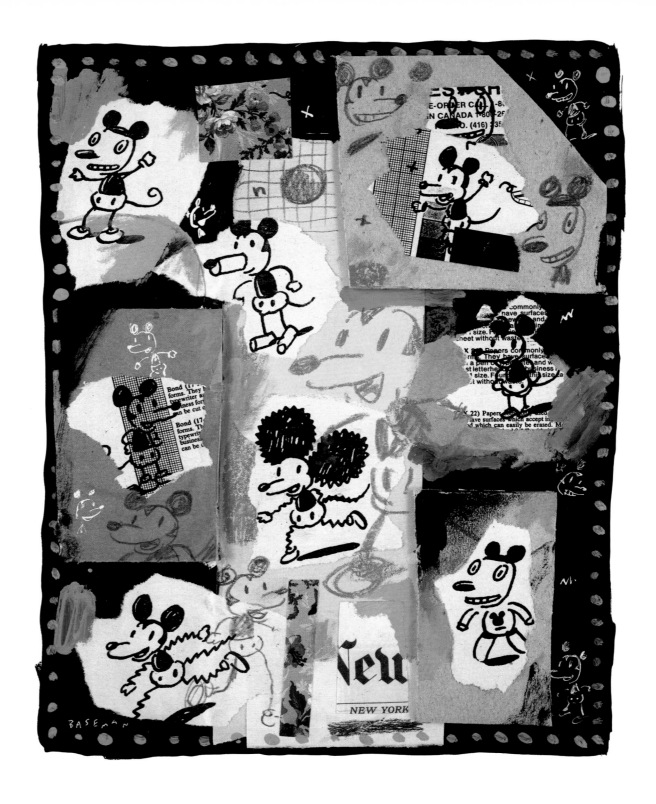

GARY BASEMAN
My Mind
Collage
34.5 x 28

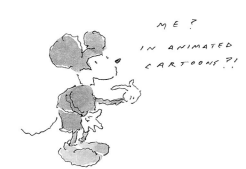
ME?
IN ANIMATED
CARTOONS?!

GOSH,
that's
WONDERFUL!

But what
do I do?

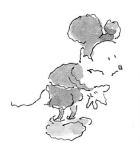
OH, I SEE...
the foot...

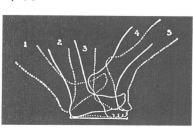

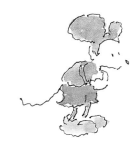
It rolls on
the ground
like THAT??

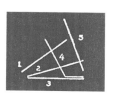

A wave motion,
eh?

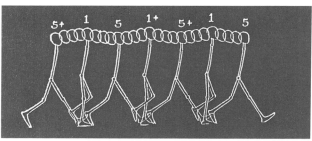

l... l... It's ...l easy
5... 5...not ...walking!

R. O. BLECHMAN
Mickey Goes to Hollywood
Mixed media
30 x 28

BEN VERKAAIK
Untitled, c. 1987
Oil on wood
45.7 x 60.9

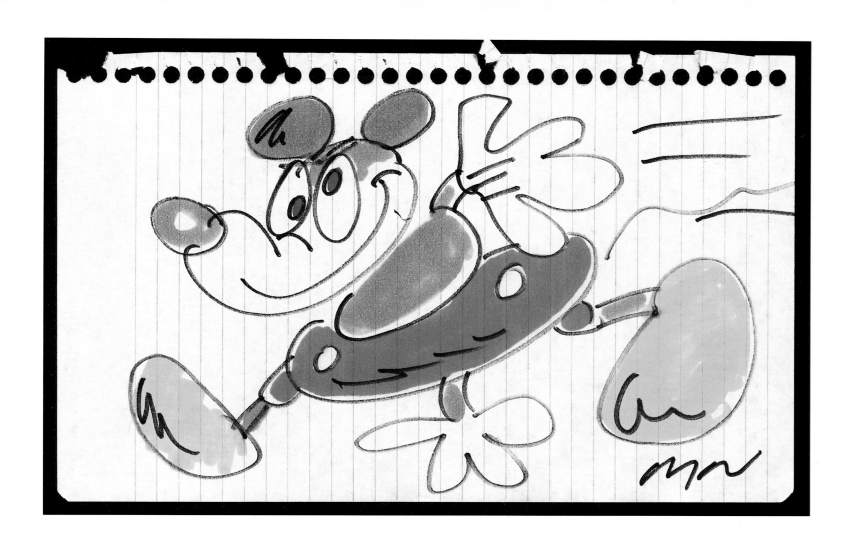

MARK NEWGARDEN
Instantaneous Gratification
Marker on line paper
21 x 30

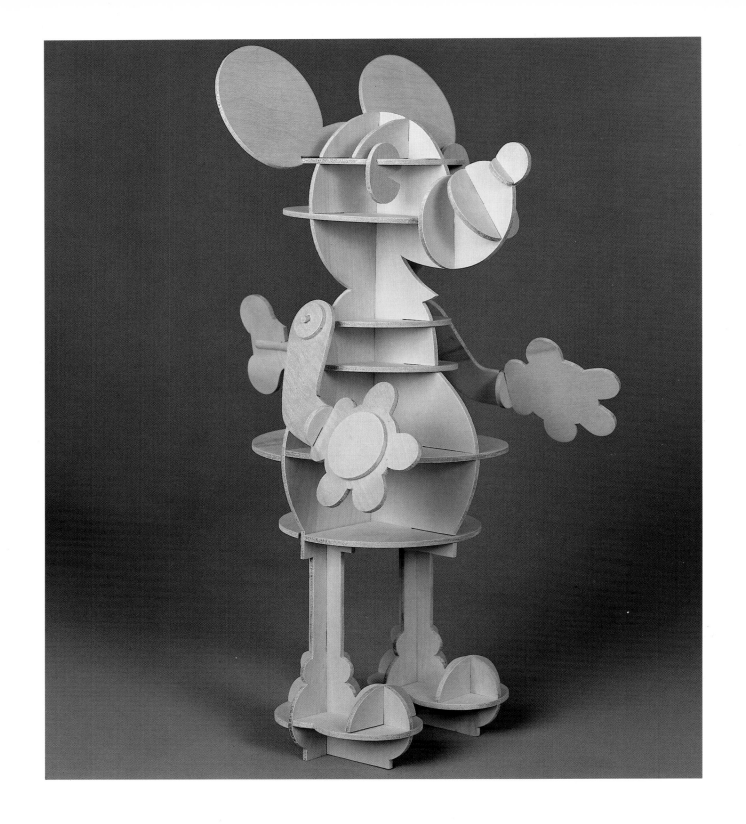

WILLIAM SHELLEY
Das Maus Puzzle, 1989
Birch
68.5 x 33

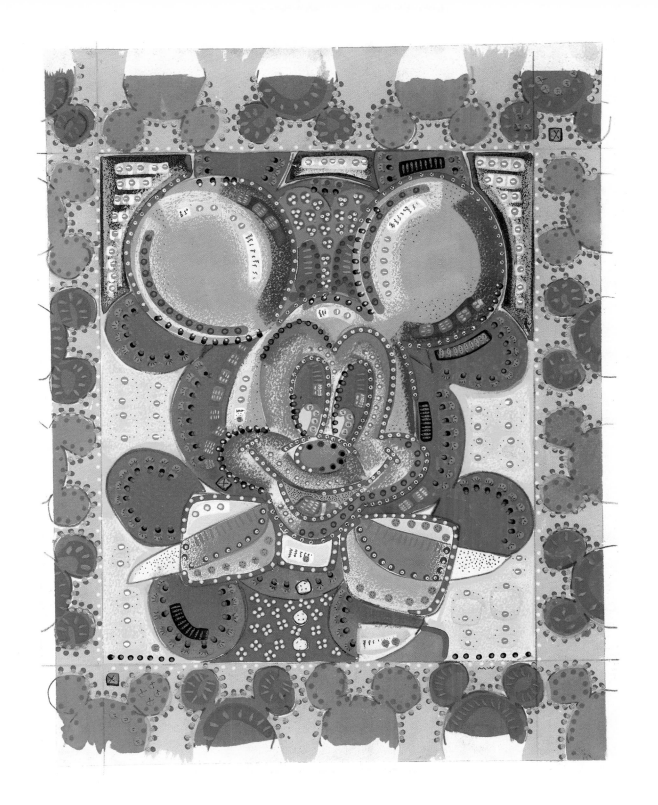

MARK WIENER

Mark's Mickey with Bow Tie II
Mixed media
44.2 x 30.4

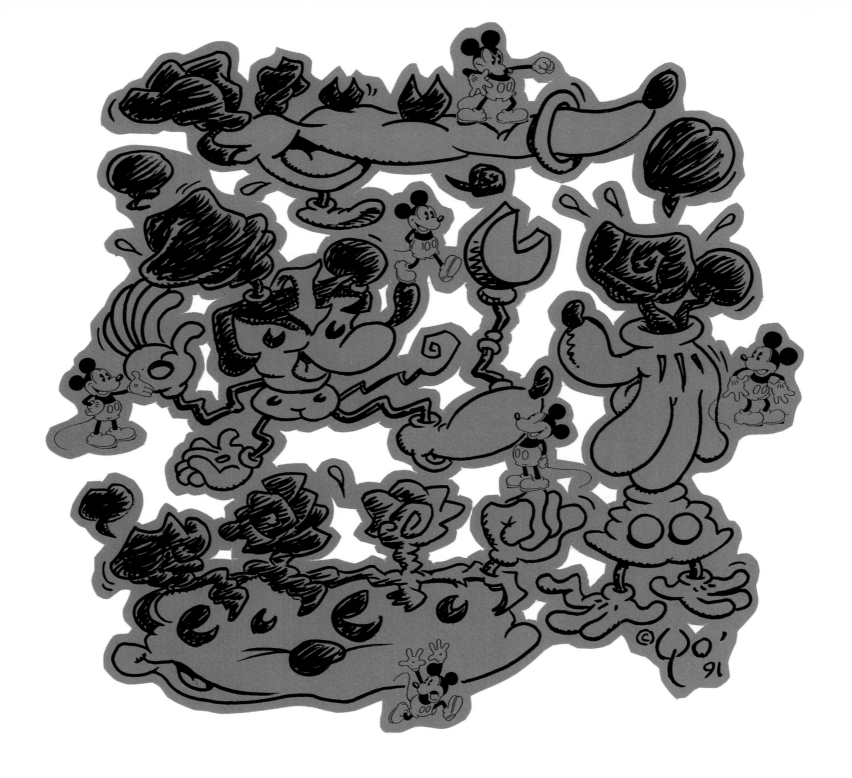

CRAIG YOE
Mickeys, Not Mickeys
Mixed media
28.5 x 28.5

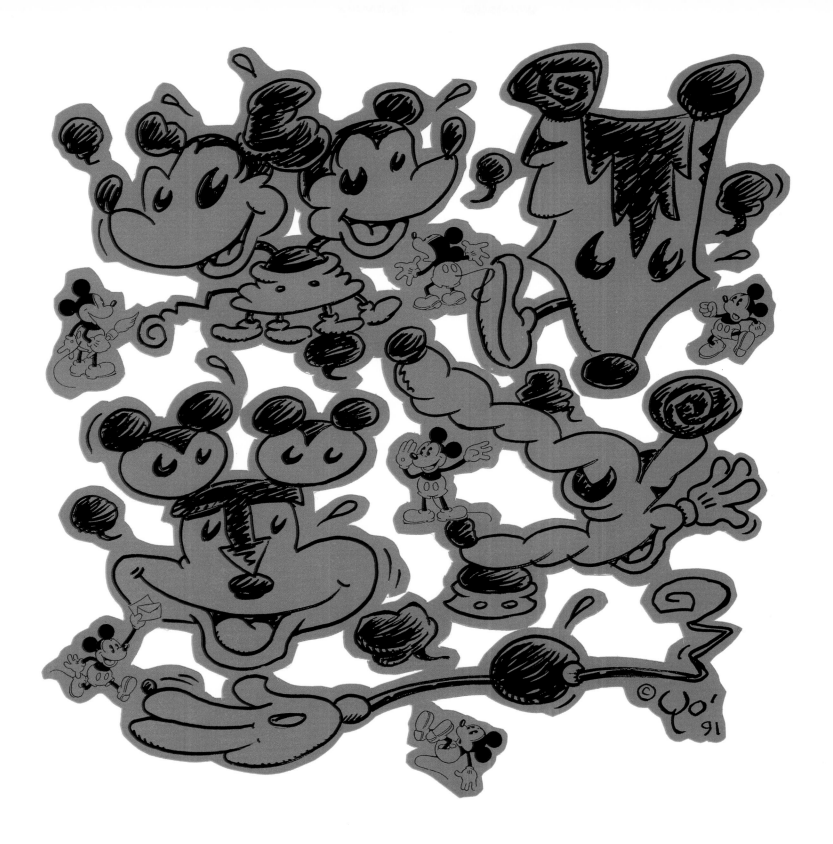

CRAIG YOE
Mickeys, Not Mickeys
Mixed media
28.5 x 28.5

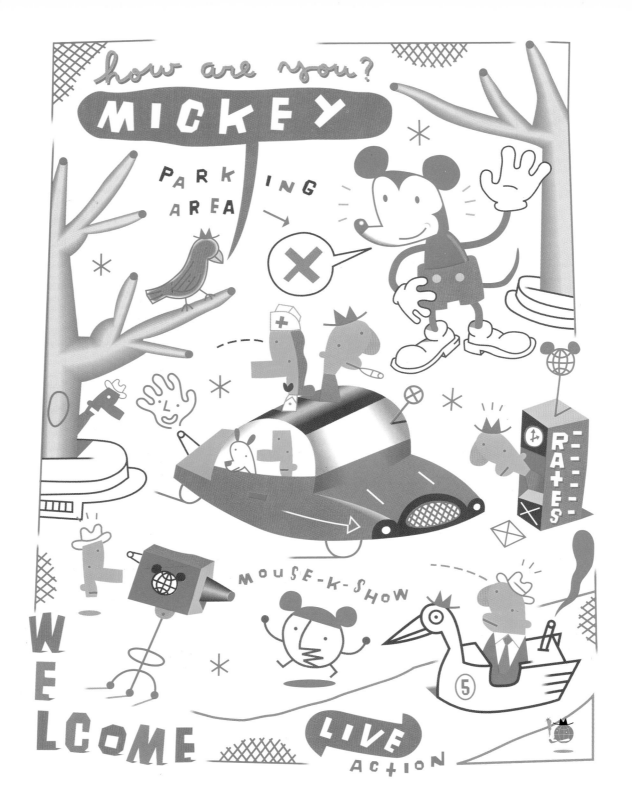

J. OTTO SIEBOLD
Mr. Mickey's Lot
Mac computer

∞

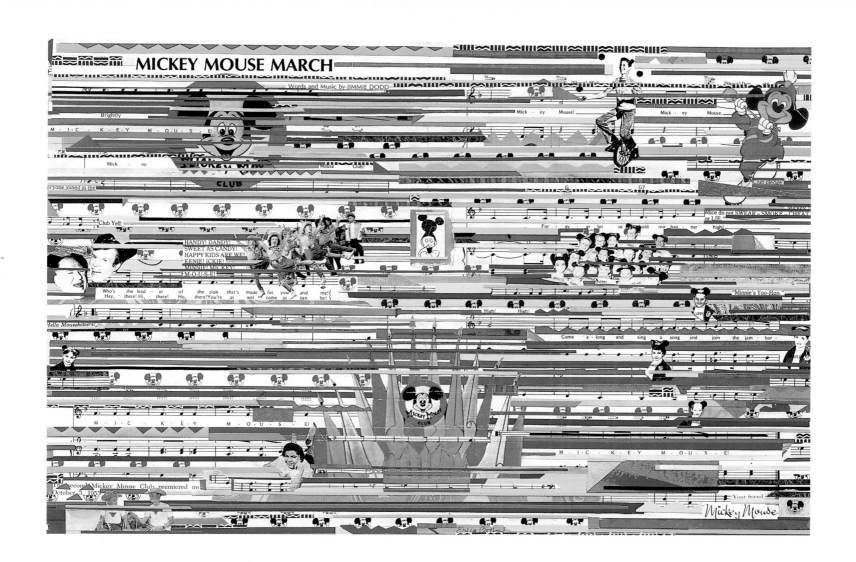

ERICA BOGIN
Hey There, Hi There, Ho There, 1990
Collage
30 x 45.2

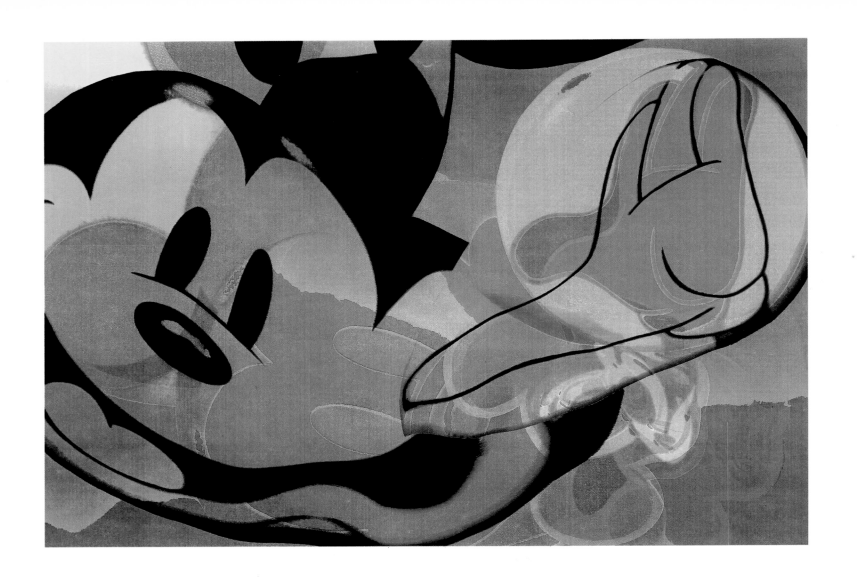

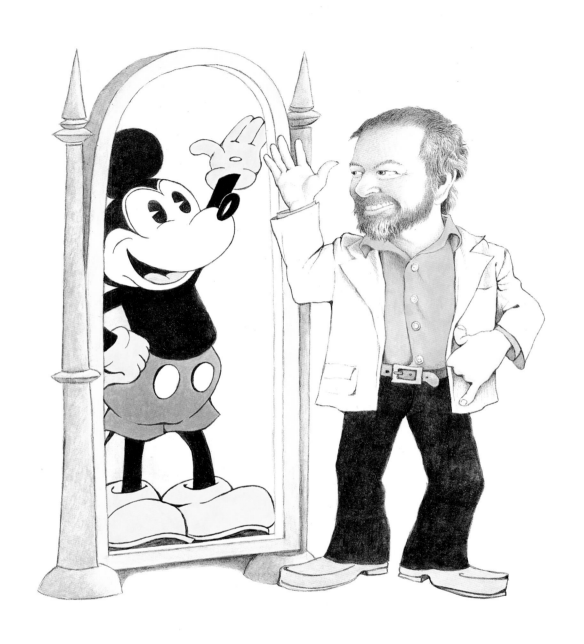

MAURICE SENDAK
Untitled, c. 1978
Tempera and brush
15.3 x 11.5

LOU BEACH
Moody Mouse, 1983
Collage
31 x 27

JOHN CEBALLOS

Mickey's Mission, 1988
Acrylic
48.3 x 38.1

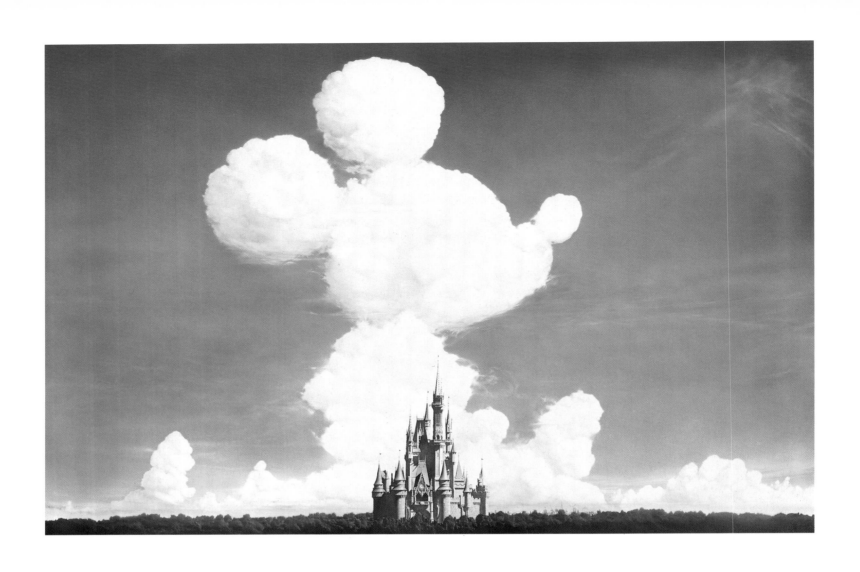

AKIRA YOKOYAMA

*Summer Vacation of
Dreams and Magic*, 1985
Gouache, acrylic and color inks
65 x 103

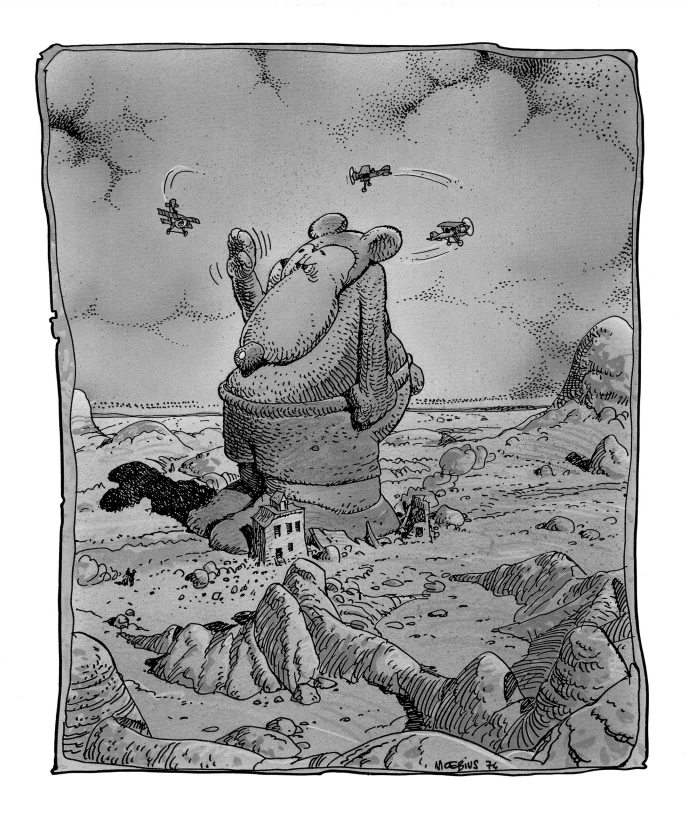

MOEBIUS

Le Petit Mickey, 1979
Pen and ink, color inks
25.5 x 30.5

ANDY WARHOL

Double Mickey Mouse, 1981
Silkscreen ink on synthetic polymer
paint on canvas
152.4 x 152.4

JOHN FAWCETT

Mickey Is Not a Mouse —
Mickey Is Great Art #2, 1985
Mixed media, pen and ink
96.5 x 129.5

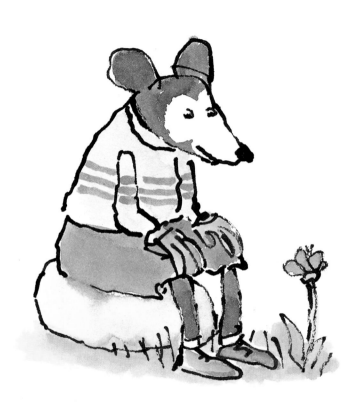

WILLIAM STEIG
Mickey Mouse I
Ink and water color
18.5 x 25.5

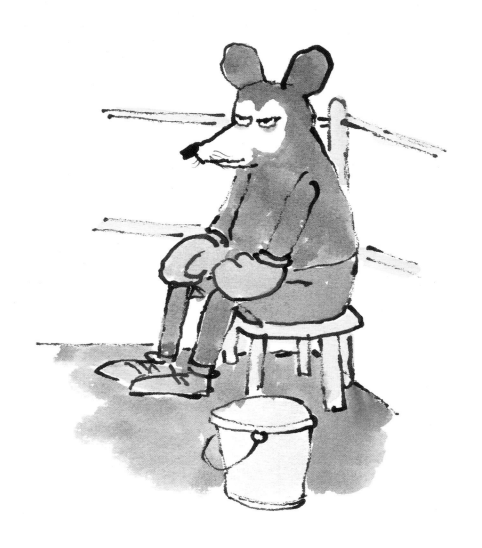

WILLIAM STEIG
Mickey Mouse II
ink and water color
18.5 x 25.5

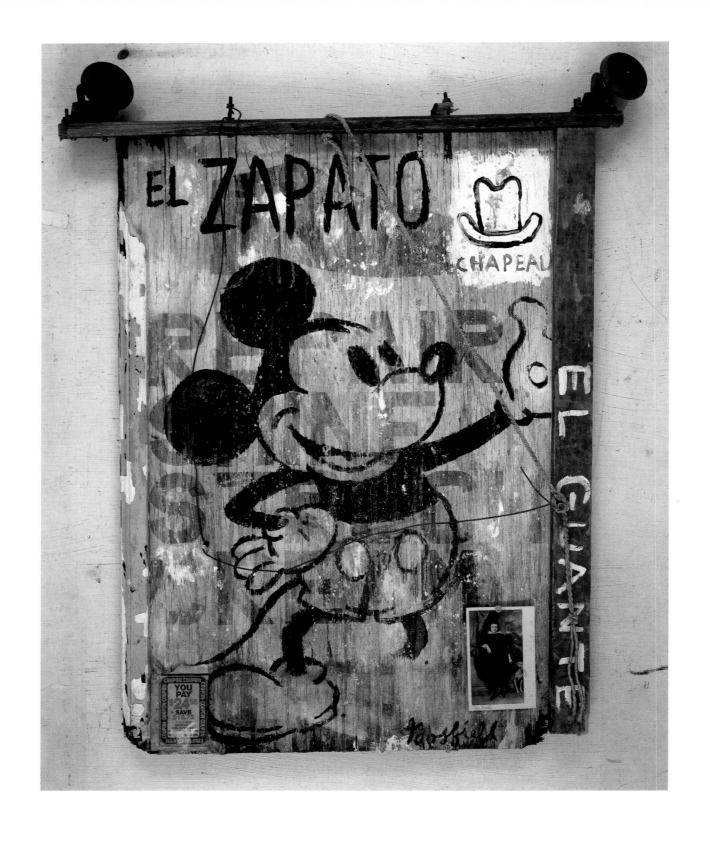

JOSH GOSFIELD

El Zapato
Mixed media
89 x 79

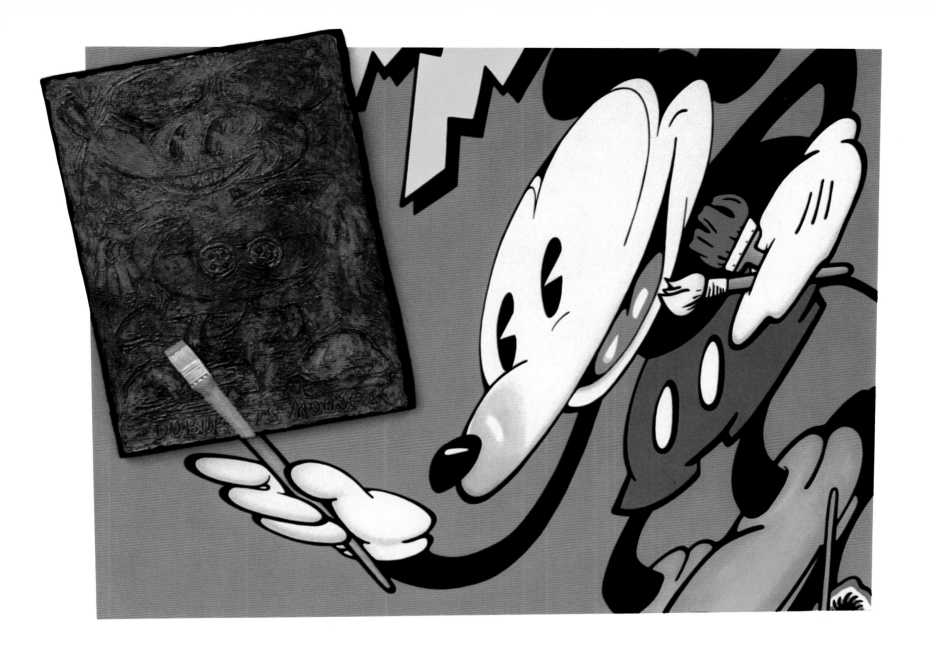

JOHN FAWCETT
Dubuffet's Mouse, 1990
Acrylic
91.4 x 122

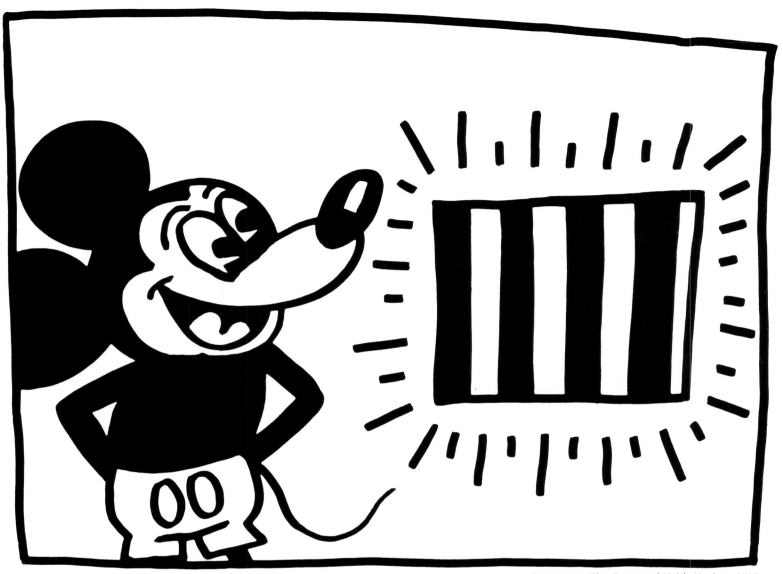

Courtesy: *The Estate of Keith Haring, NYC*

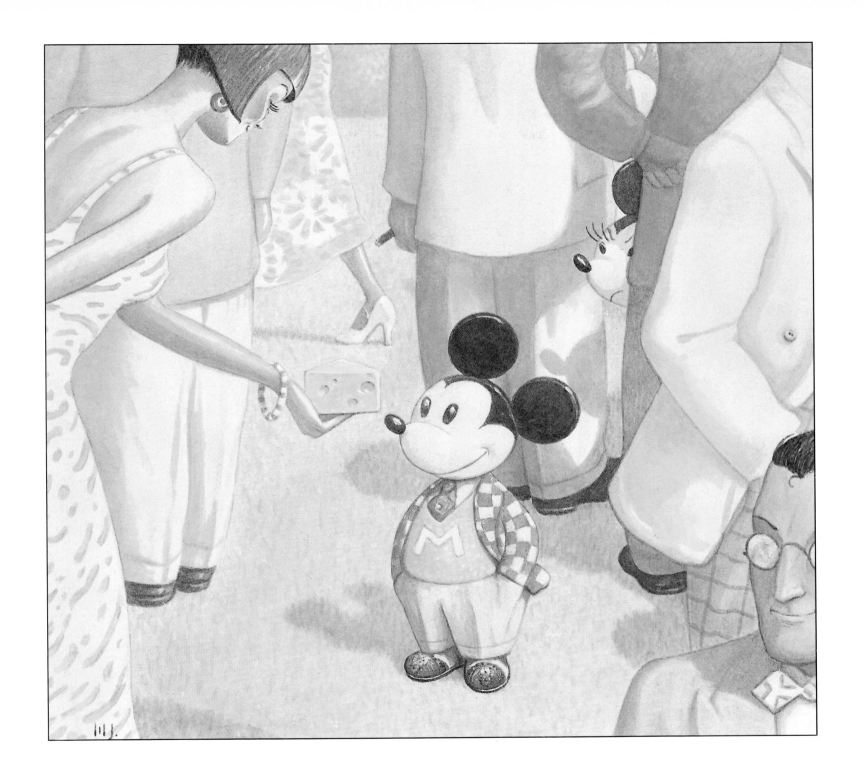

WILLIAM JOYCE
The First Temptation of Mickey
Acrylic
19.4 x 23.4

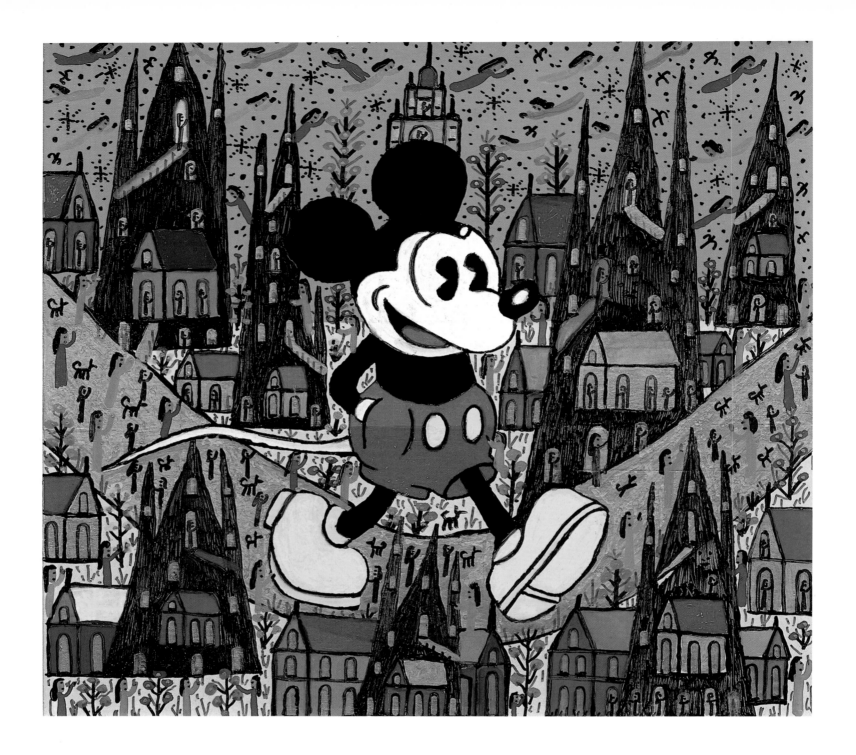

HOWARD FINSTER
*Howard Finster Puts Mickey
Mouse in a Kid's World* (Detail)
Enamel on wood
52.1 x 56

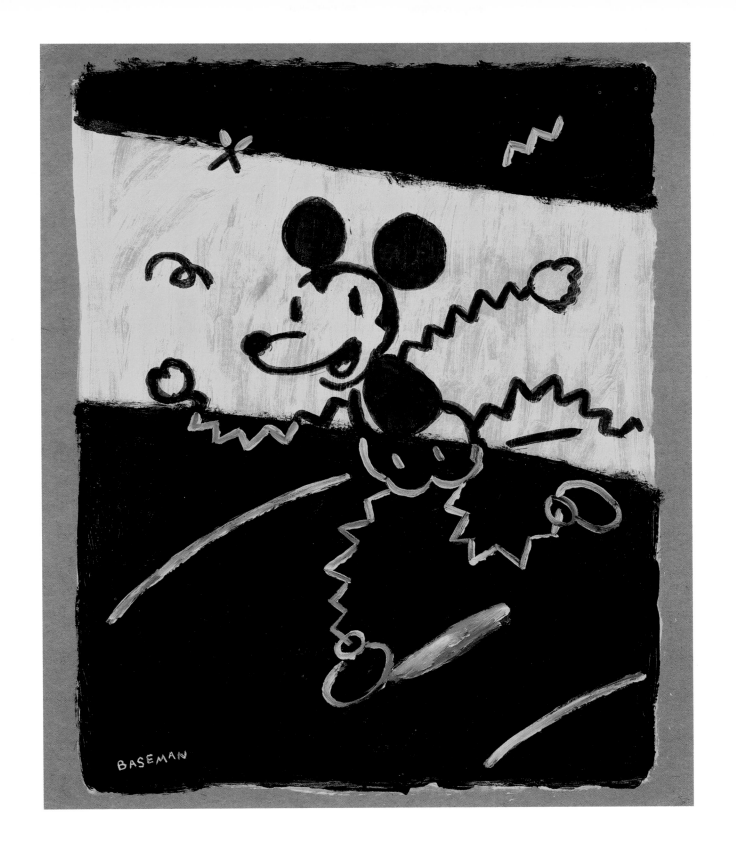

GARY BASEMAN
Electrical Current
Ink and acrylic
50.7 x 40.5

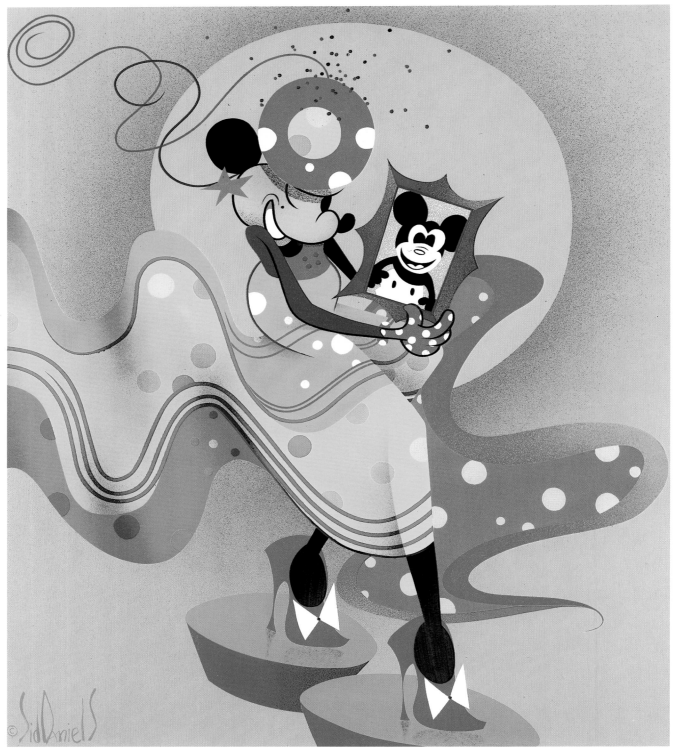

SID DANIELS
Star Struck
Acrylic on canvas
122 x 106.6

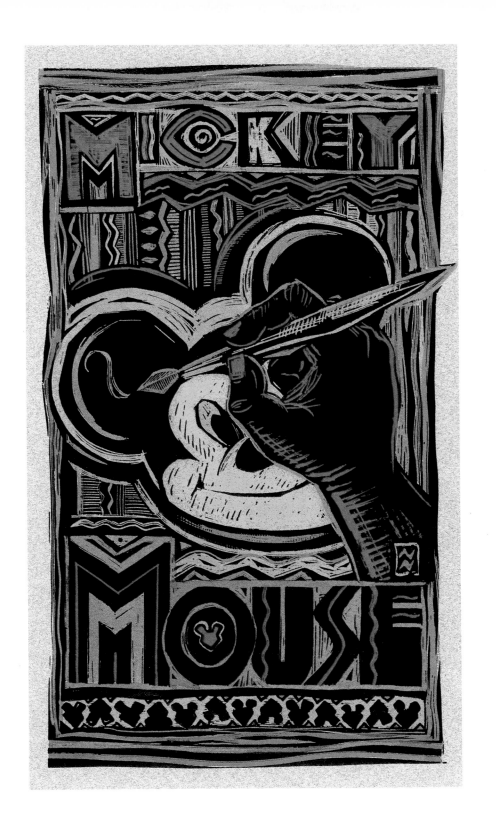

NANCY NIMOY

Untitled
Scratchboard and water color
26 x 15

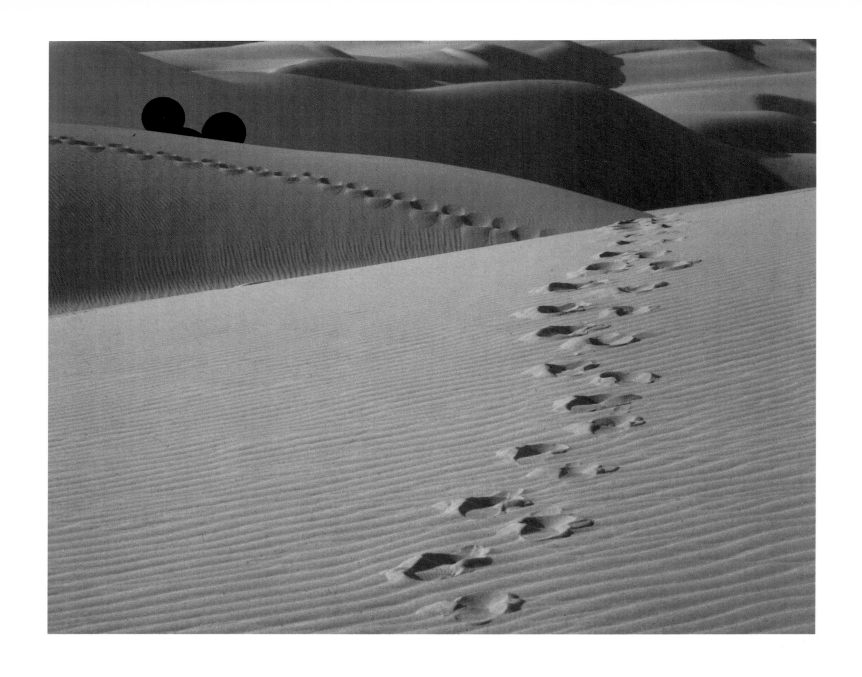

SAUL BASS
Mickey in the Mojave
Color photo copy and overlay
20.3 x 25.5

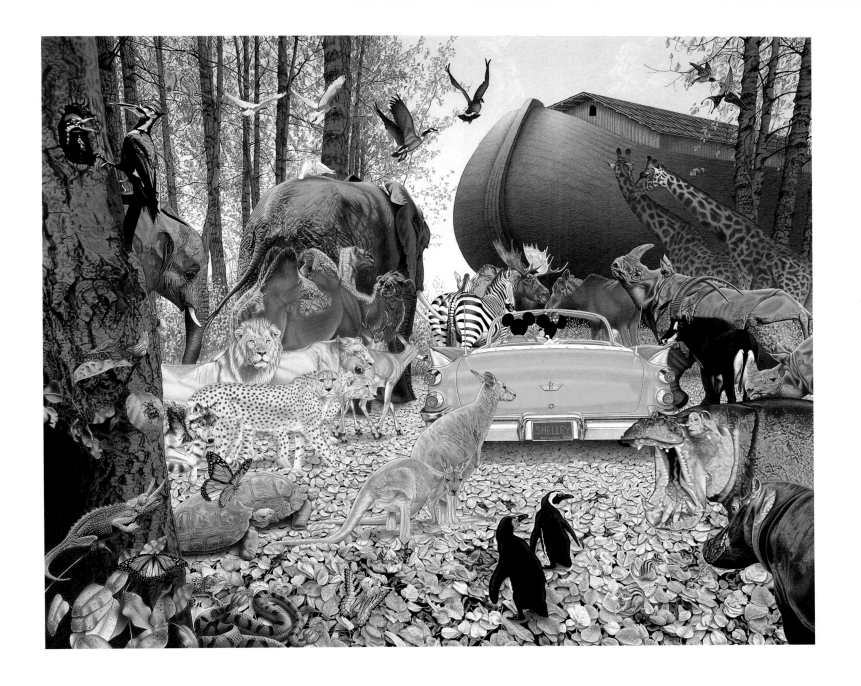

SHELLEY BROWNING

Noah's Ark, 1987
Acrylic
35.5 x 43.5

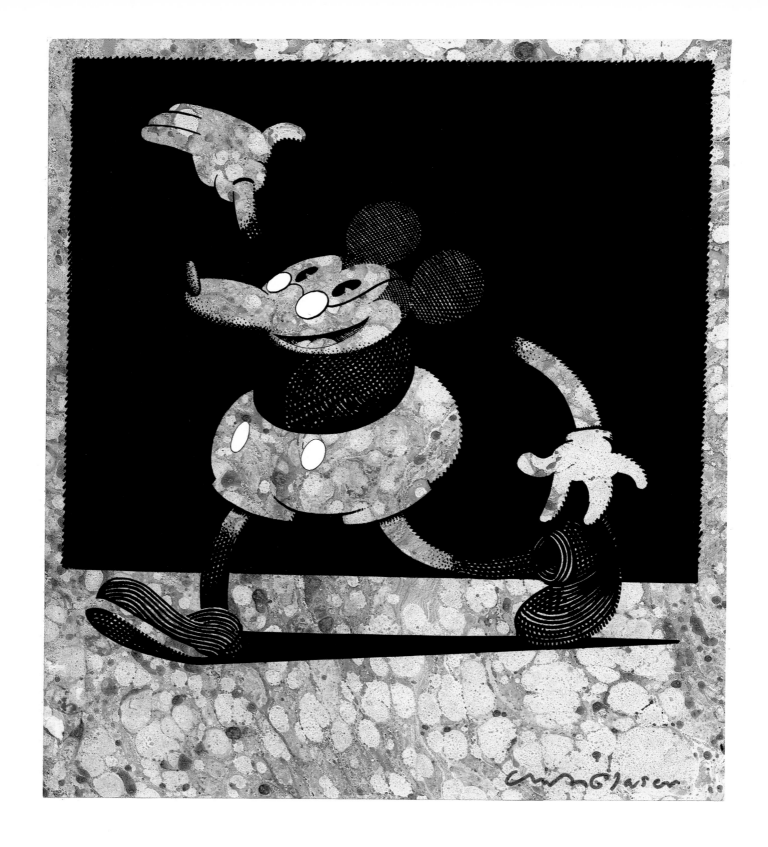

MILTON GLASER
Mickey Mouse Grows Old
Ink, ornamental paper
30 x 25.5

ACKNOWLEDGMENTS

A tip of our Mouseketeer ears to the following people to whom we're deeply indebted for their help...

Even though this is an "outside artists' " book, many people within the Disney organization made it possible. First, Liz Gordon believed in us and was sure we'd come up with a good idea for Walt Disney's new publishing company, Hyperion. We hope we've proved her right. Bob Miller, our editor, sacrificed, pushed and held the vision through the intense birth process of this volume. Steve McBeth and Michael Lynton's strong leadership and gracious assistance were invaluable. Esther Ewert, head of the Disney Art Program, had an expert artistic eye and gave us much encouragement.

Martha Kaplan's great humor, wisdom and encouragement saved our sanity more than once. Her terrific editorial insights added much to this book.

Victor Weaver's consummate taste and accommodating attitude were always appreciated.

Linda Prather is a top-notch production director, and we were thrilled to have her on the team.

Disney Imagineers were a great inspiration and help. Thanks to Marty Sklar, Mickey Steinberg, Maggie Elliott, Eric Jacobson, Kathy Rogers, Rose Likes, Peggy Van Pelt, Tim Kirk, and all of our many other friends there.

Everyone who does a Disney book is very thankful for the Disney Archives headed by David Smith. Thanks also to Rose Motzko for her assistance.

Michael Mandry of Euro-Disney, in Paris, was an excellent overseas contact.

Our deep gratitude to Bob Ogden, Peggy Garry, Joette Stambaugh, Mary Miyoshi, and Colleen Corrigan of the Walt Disney legal department for all their hard work.

Additional thanks to Mary Ann Naples, Chuck Totaro, Tim Onosko, Dale Moore, Lisa Kitei, Sarah Peterson, Vicki DiStasio, Lesley Krauss, Kate Rey, Tom Sito, Gary Albright, Russel Schroeder, Ellen Friedman, Peter Schneider, Marcy Goot, Tom Schumacher, Annie Stevens, Kristin Kliemann, Dorit Kinkel, and many other Disney people.

Art historian Barry Blinderman provided expert counsel on the Disney/Warhol/Haring relationship. Obtaining the Warhol art was greatly aided by Ron Feldman, Susan Yung, and Elizabeth Weisberg. Equally enthusiastic were Julie Gruen and David Stark at the Keith Haring Estate.

Peter Max appears with the generous help of Lisa Usdan and Frema Gluck.

Michael Jackson's art would not have graced these pages without the kind determination and help of Norma Staikos and Evvy Tavasci at MJJ Productions. We'd like to thank them, and also Craig Shemin, who helped make this possible.

Nancy Rosen was an excellent art consultant to us.

There hasn't been an important project in the last 20 years for which we haven't sought the help of Don and Maggie Thompson. On this book they, again, were most helpful.

People providing welcomed ideas on artists we might consider or the information on how to contact them include Marisa Bulzone/Graphis, Mark Newgarden, Luis Gasca, Katia Steiglitz, Peter Kuper, Terry Thoren/Expanded Entertainment, Jackie Estrada, D. Dodge Thompson of the National Gallery,

Jim Lilie, Ellen Friedman, Shel Dorf, Roz Kirby, Phyllis Flood/Pushpin Associates, Jan Arnesen, Phyllis Kind/The Phyllis Kind Gallery, Julie Moreton, Richard Wilde, Honor and Monte Wolverton, Lora Fountain, Mark Wiener, Michelle Stuhl, Perla Levy, Jay Lynch, Bob Panzer, Pam Sommers/The Illustration Gallery, Tony Bennet, and Kerig Pope.

Also, John Carlin, Yusaka Kamekura, Abby Turkuhle, John Payson, Katie Dunkelman, Susan Guest, Jacaeber Kastor/The Psychedelic Solution, Pierre E. Bocquet, Paul Gravett/Escape, Glenn Bray, Bill Spicer, John Locke, Willem Naber/Strip Schrift, Randy Maid, Gilbert Shelton, Miriam Sursa, Bill Hawk, Paul Theibaud, Jean-Marc and Randy Lofficier, Frank and Jeff Lavaty, Patrick Flynn, Lisa Eue Huberman, and Byron Werner.

More aid came from Peter Rosenthal, Jenni Holmes, George Englebrecht, Adele Solomon, Mike McGonical, Alan Lynch, Frank Olinsky, Pat Gorman, John Fawcett, Ray Johnson, Robert Laughlin, Steve Cerio, J. D. King and super-creative Scott Webb of Nickelodeon, and long-time friends Dave Scroggy and Paul Mavrides.

Fellow authors whose beautiful books in related fields were a great inspiration and who unselfishly advised us along the way were Brad Benedict, J. Michael Barrier, Tommy Steele, Stephen Heller, Maurice Horn, Russ Cochran, and Christopher Finch. Friends in this category include John Canemaker, Jay Kennedy, Ron Goulart, Patrick McDonnell, Karen O'Connell, Art Speigelman, Maria Reidelbach, Glenn Bray, Ray and Gail Zone, Rick Marschall, Bill Spicer, Dug Miller, and John Stanley.

Providing incredible help in production were designer/type setters Warren Smith, and Sherri and Richard Sheridan. Also thanks to Marc Weinstein.

A big thank you to Ruth Nathan, our incredible agent.

Brad Thompson is both a good friend and, as one of the world's highest regarded designers, a tremendous inspiration.

J. J. Sedelmaier, who works minutes away, and Mayumi Kubota, who works halfway around the world, became our good friends while helping on the book.

Nancy Connors, our friend, neighbor, and expert editorial muse, spent much time with us on this book, often sharing our late night hours.

We very much appreciate Jeff Kellgren and Jackie Gibbs who worked as trusted translators when we dealt with artists, museums, and galleries overseas.

Thanks also to Mort Todd, Chrissie Hynde, Bud Plant, Gary Groth, Jerry Gross, Sheryl O'Connell, Frank Thompson, Robert Heide, George Erling, Claes Oldenburg, Mark Martin, David Platsker, Bob Panzer, Dottie Oriolo, Judy McGrath, Linda Siminsky, Jeanne Steig, Alan and Sue Kolod, Maria Modica-Snow, John Magnotta, Gerry LayBourne, Heidi Diamond, Amy Javors, Rich Cronin, Denise Shapiro, Michael Frith, Lauri London, Arthur Abelman and especially Carmen Grundlehner.

Heartfelt gratitude to our supportive loved ones Betty Yoe, Jean Ann Bender, Lynn Darkow, and Boody and Mary Rogers.

Finally, the memory of Jim Henson's love and creativity often sustained us through this project.

The type for *The Art of Mickey Mouse* is Americana. The majority of the specially commissioned art was photographed by Gamma One Conversions, NY. Color separations, printing and binding provided by L.E.G.O. Legatoria Editoriale Giovanni Olivotto S. P. A., Vicenza, Italy. The Paper is Gardamatt Brillante 100# manufactured by Cartiere del Garda, Riva Del Garda, Verona, Italy. Measurements for the art are in centimeters.

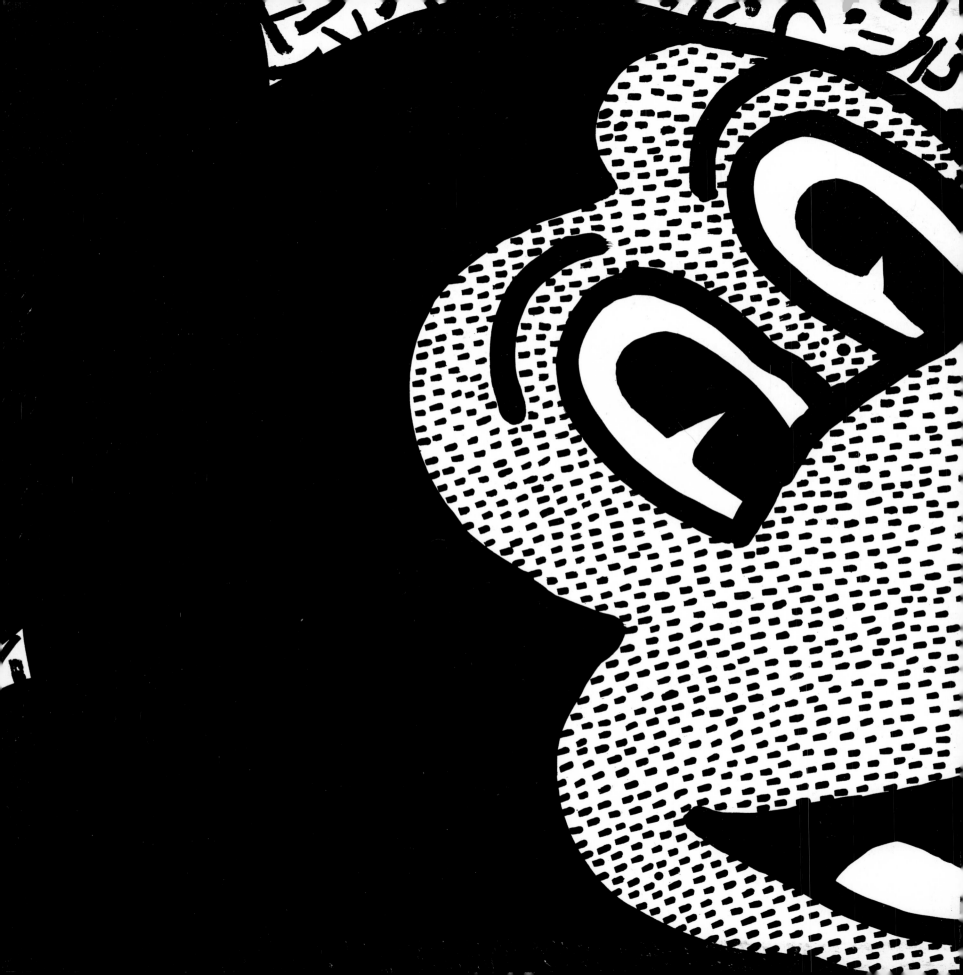